MI
ANGL
GHOSTS

MORE ANGLESEY GHOSTS

BUNTY AUSTIN

AMBERLEY

First published 2011

Amberley Publishing
The Hill, Stroud
Gloucestershire GL5 4EP

www.amberleybooks.com

Text © Bunty Austin 2011
Cover image © Gail Johnson | Dreamstime.com

British Library Cataloguing in Publication Data.
A catalogue record for this book is available from the British Library.

ISBN 978-1-4456-0332-2

Typesetting and Origination by Amberley Publishing.
Printed in Great Britain.

Contents

Acknowledgements

For my dear Walt, who died so suddenly last September, and for the tightly knit group of friends and neighbours whose kindness and love I will never be able to forget – they saved me from the depths of despair.

Also my thanks to Mrs Manon Williams, who very kindly and professionally created order out of my chaos. And to the ladies of Amlwch Library and the ladies of Llangefni Archives for all that they have done.

God bless you.

Bunty Austin
2011

Foreword

Here, at last, is my fourth book about ghosts.

I had great fun writing it, and have made a host of new friends, mainly Islanders. They comprise poets, poachers, teachers, postmen – people of all walks of life – who have kindly told me about their ghosts. I have made hundreds of gallons of tea and we have toasted our toes in front of roaring fires.

The people of the Island are delightful, courteous, kind and most friendly, with a deep sense of humour that ripples out as soon as it is tapped.

I was immensely thrilled when I was thanking someone for her help one day and she said, 'Well, Bunty *bach*, you're one of us!'

Perhaps this is because I once lived on an isolated farm in beautiful Derbyshire, where we had to light a fire before we could make a cup of tea and the long winter evenings were illuminated by paraffin lamps. I was fairly 'ghost-soaked' before I came to this beautiful Island, and after nearly ten years of being headmistress of a country school, ghosts and their stories are not strange to me.

Although Walt and I were newcomers, we were both country folk, and had suffered from the 'townie outcomes' (so named because they came out in droves from the towns) who tried to run things as they wanted things to be and were not content to become a part of the village life that had existed for hundreds of years.

Not all are like that, thank goodness – many townies have become valued members of the community, including several of my friends.

But enough rambling. Enjoy what I hope will be a good read!

Ding Dong Bell, What's That in the Well?

If anyone who is reading this has read my first book, *Haunted Anglesey*, perhaps they will remember the story of the cobbler of Amlwch Port.

Well, this is the story of another house not far from the cobbler's, but I have been asked by the present owner of the house not to divulge its name, as she wants to sell it and move. She has given me the name she wishes to be known by (not her real one) – Peggy. So Peggy it is. Here's what happened.

One day this autumn, there was an urgent banging at my front door, the sort of knock that demands an answer. I stopped writing and came down the stairs from my office and opened it. Peggy rushed in, pushing me aside in her haste. 'Can I come in?' she asked, standing in the middle of the hall.

'I think you already are in!' I said, shutting the door. She barged into the sitting room, flung herself onto the settee, and sat twisting her scarf into knots, staring around as if she'd never seen the room before.

I could see something was wrong. Peggy is usually very calm and controlled, but that day she looked wild. 'Do you want me to make a cup of tea now, or when you've told me whatever's on your mind?'

She brushed aside the suggestion of tea with a wave of her hand. 'Listen,' she said, 'but promise you won't say a word to a soul?'

I shook my head.

'People will think I'm crazy', she said, 'but I've got to tell someone.'

I thought wryly that if I had a pound for every time I'd heard that, I'd be very rich indeed. What follows is the gist of her story.

'Well, you know Bill has been staying with me?' Bill is Peggy's brother and lives in Yorkshire. 'He went back on Wednesday. I was sorry to see him go, he's good company, but so untidy! I thought I'd have a relaxing night in, and watch TV, but as I switched the light on I knocked a little ornament off the top of the TV set and it fell down the back.' Peggy has a new TV in a very nice polished-oak cabinet with closing oak doors

– rather old, but it fits the room. 'Well,' said Peggy, 'I bent down sideways to pick it up, and I looked behind the TV. As I looked down, well… The TV was standing on the edge of a pond!'

'The edge of a what?' I asked.

'A pond. Oh, I know this sounds mad, but instead of the corner of the room, there was a pond, with reeds and stuff growing at the sides of it. I stared at it for a bit, then I straightened up, and as I did so, the pond just disappeared, and I was gawping at the wallpaper and the carpet. Well I thought it was just a hallucination or something. I tried to put it out of my mind, but I thought about it all day. I went shopping in Amlwch next morning, and when I came back I sat down to read the paper. I must have dozed off because I came to with a start and everything in the room seemed to have gone funny.'

'Funny, how funny?' I asked her.

She thought hard and frowned a bit. 'Well, all the furniture seemed sort of flat, as if I was looking at a photograph, and the air was very still. I knew something was going to happen. Trim had been asleep on the sofa, but he suddenly woke up and looked around the room.' Trim is Peggy's rescued greyhound. 'Then he whined and came and hid behind my feet. I could feel him trembling and his neck hair was all stiff. I felt very scared suddenly, and I shivered, then the room seemed to fade out somehow, and everything changed.

'I was looking at the tree at the bottom of my back garden. I knew it was the same tree, but it was much thinner, and not as tall. And it wasn't growing in the garden; it was part of a field, and there weren't any houses around like there are now. The pond was there too, I recognised the shape, and the rushes at the side.'

I interrupted her. 'What time of the year did you think it was? Were there leaves on the trees? And was it morning or afternoon?'

Peggy thought for a moment. 'Oh, I think it was summer. The grass was all green, and there were leaves on the trees, and it was late afternoon, nearly dusk. As I was looking, I saw a man come into the field with a pony and trap. I don't know what you call those little carts – dog carts, governess carts, whatever. I call them pony traps. Anyway, everything looked so real. I was there, I could feel the breeze on my face, and I could hear the harness jingling. The man leading the pony was short and stocky and middle-aged. He had a thick moustache, and he was dressed in rough working clothes – a shirt with no collar and an old waistcoat buttoned up, with a jacket on top.'

She stopped and turned to me. 'I couldn't move. I was frozen to the chair. Suddenly there was a loud knock on my front door, and the whole picture started to melt. It rippled from the sky, and I had to get up and answer the door. My legs were all trembly, I felt so dizzy.

'It was the postman at the door. I had to sign for a parcel. When I'd done that I made a cup of tea. I kept thinking about what I had seen, and I wondered whether I was going a bit loopy.

'Anyway, I made a cheese sandwich with my tea, and I sat down to eat it when it happened again. The same field, and the same man and pony. This time the man came towards me. I was scared stiff, but I couldn't move. I was there; I could feel the grass under my feet.

'Then I realised I could see him, but he couldn't see me, even though I seemed to be standing just a few yards away.

'Then he stopped. I saw that there was a deep hole dug at the edge of the field, down a bit of a dip in the earth. The man stopped at the edge of it and looked down at it, and then he looked around. It was a lonely spot, not a building in sight. The farmhouse was over the hill, but I think he was making sure there was nobody about.

'He went back to the pony and trap. I noticed it was standing on an old cart track, and he went to the back of the trap, got hold of something heavy, and started to drag it out. It thumped onto the ground, and I saw it was a body.'

I felt my jaw drop. I'd heard many strange stories in this room, but this was one of the strangest.

'Then he dragged the body across the grass to the hole. It took him a long time. He kept having to stop to get his breath back, and he'd look round all the time to make sure that there was no one about. He couldn't see me, but I felt I could reach out and touch him. I realised then that the hole was really a grave.

'He left the body at the edge, and went back to the cart. I could see it all quite clearly. The body was a young man, lying on his back, I could tell he was dead because his jaw was dropped, and his eyes were half-open and rolled back. He was very good-looking with curly hair, but there was a big patch of dried blood on his forehead, above his left ear.

'Then the middle-aged man came back with a spade. He rolled the body into the hole and started to fill it in with a big pile of soil that was on the side. He kept getting in the grave and stamping the soil down, but there was still some left over when he'd finished, so he scattered it over the field with the spade.

'I could see that he'd cut the turf off carefully when he'd dug the grave, and he put all the pieces back to cover the new soil, then he stamped it all level until you couldn't tell the difference between the place where the hole had been dug and the rest of the grass.'

I interrupted here. 'Peggy, is this all true, or are you making it up?'

She stopped gazing into the fire and glared at me. 'I knew it; I knew nobody would believe me!'

'Well,' I said, 'you must admit it sounds a bit far-fetched!'

'It's the truth,' she said vehemently. 'I swear it's the truth. I've never told you a lie. Oh, I wish you'd believe me, I don't know what it was, or why I should see it!'

'OK, OK,' I said. 'Calm down and finish your story.'

'Well,' she said, a bit sulkily, 'there's nothing else to tell. He started to walk back to the pony and trap, and then suddenly it all went dark and vanished.'

'Well, who was he?' I asked.

'I don't know, do I?' she said in exasperation. 'I haven't got a clue. It was dead scary.'

'Has it happened since?' I asked.

'No, thank goodness, and I don't want it to either. I just thought I had to tell you, since you're interested in ghosts.'

We sat there in silence for a minute or two, both busy with our own thoughts. I was trying to work out who these people were, and whether there was a reason for them

appearing to Peggy, or whether it was an ongoing occurrence that she just happened to witness. 'Tell you what,' I said, 'how about me coming down to your house and you can show me where it happened?'

Peggy jumped up. 'Oh good, I hoped you'd say that, let's go right away.'

So off we went – down to Peggy's cottage in Amlwch Port.

When we got there we went straight through the house into the back garden. It was long and narrow, and it ended with a dry-stone field wall. Near the wall stood a mature tree, just as Peggy had described.

Beyond the garden lay fields. They looked like rough pasture, with uneven dips and hillocks in the grass. A little brook ran down from the gentle hills above, on its way to the sea. 'You see there is no pond now. It was just about there I think.' She pointed. 'Looks like it's been drained again. Probably it was a stream at first, then somebody dammed it up to make a pond and now it's running through the pastures again. Water for the animals, I suppose.'

We leaned over the wall. 'Whereabouts was the grave?' I asked.

Peggy swivelled her head from side to side. 'Oh, it all looks so different now,' she flapped her hand vaguely. 'I think it was about there somewhere.'

I looked around the rough pasture. It was a gently undulating piece of land that rose gradually into a small hill, with plenty of innocent-looking hollows and ridges. The farm it belonged to was out of sight on the other side of the hill. A small flock of sheep moving over the rough grass was the only life to be seen. The wind blew cold into our faces; we shivered and turned to go inside.

Inside the house, Peggy took one look at my face and said, 'You do believe me, don't you? I wasn't making it up.'

Of course I believe you,' I said, 'I was just wondering how I can find out what happened and when. Tell me what you know about the farm that the field belongs to.'

'Well, I do know that the land doesn't belong to the farm anymore. It's been sold, and the farmhouse is just a house now. Somebody lives there called Hibberts. They've lived there for years. They bought it off a farmer called Jones, but he retired a long time ago, and he went to live with his daughter at Cemaes. He might be dead by now, I don't know.'

'I'll try to find out what I can about the history of the place,' I said, 'Give me a few days.'

A few days? It took me months. Like a lot of this kind of research sometimes does, it didn't have a satisfactory ending. Conclusions are often nebulous and owe a lot to hearsay.

I put a lot of questions to a lot of locals – and I mean *real* locals, whose families have been here for many generations. The best people to speak to are the old people. They are the ones who have the knowledge of days gone by, mainly what they were told, or heard, when they were young. In their day, gossip was the currency of the village.

People would sit around the fire after a hard day's work, and would relate to each other the harvest of the day's events, all together as one family, in one room, three or four generations, so that the folklore and legends were kept alive. Today it is dying – most of it already gone forever. Technology has split families into fragments, each

member in a separate room, glued to television, Facebook, Twitter, etc. Most of these things are so shallow and frivolous, they are forgotten in a week. But back to the few facts I gleaned about Peggy's vision. Facts, did I call them? They were never recorded in print, and these 'facts' always begin in the same way. 'My Grandfather used to tell me stories about the village.' Or, 'When I was little, my Mam used to say...'

Putting all the snippets of stories together the best I could, this is what I gleaned. In the 1890s the farm belonging to the Joneses was large and prosperous, rearing cattle and sheep in large numbers.

It was also an arable farm, having many acres of oats and wheat. There was a big demand for meat, as the copper mine was thriving then and employed hundreds of workers.

Farming was one of the biggest industries for men on the Island. Women were needed to keep the flocks of poultry for eggs and cooking fowl, and also to make butter and cheese, not to mention the bread making and cooking for hungry farmworkers.

The permanent farmworkers were augmented at times by an annual influx of itinerant men, mostly Irish, who travelled from farm to farm during the busy season. They were taken on by the farm foreman, who was the overseer of the outside labouring force. Mostly these temporary men slept in the outbuildings, mainly in the lofts or in a corner of the barns or stables. The life was rough and hard, but the wages, though small, were regular, and the food was ample and homemade.

At the Joneses' farm, the foreman, Huw, lived in a small earth-floored one-storey cottage in the grounds. He was middle-aged, a hard man, and had a quick temper. Disliked by all, he was nevertheless fair in his judgements. He never ordered the labourers to do any task he wouldn't do himself. So while the men cursed him quietly, they respected him.

Huw's young wife, Betsan, was a housemaid at the farm. She had been pushed into the marriage, very unwillingly, by her parents, who knew that Huw had a very secure job at the farm, was frugal with his money, and also had a cottage. She had no choice.

It was a loveless marriage. He needed a cook and housekeeper, and she needed security. He wasn't a kind man, but nor was he violent – he treated her very fairly. Her parents were pleased with the match, so life went on.

While making enquires, I was told by a gentleman in his eighties (who had listened to yarns told by his grandfather when he was young) that one year in the 1890s at hay-making time, a young ostler had arrived at the farm, asking for work. The foreman gave him the job of getting the horses ready for work.

Watched closely by the stocky, stem-looking man, Tim – as the ostler was called – did the job quickly and deftly. He was from Ireland, aged twenty-four, healthy and not afraid of hard work.

The sleeping lofts were full, so Tim bedded down in the barn. No hardship there; the hay was soft, loose and comfortable.

He was a shy lad, and liked by the rest of the men. The temporary ones spent many of their evenings in the pub – where most of their wages went – but the men who lived locally went home to their wives each night.

In those days, there were no showers, or even running water. Tim and Betsan often met at the well in the early mornings, she filling pails for cooking while Tim went

down for water for his wash and shave. They also met daily in the farm kitchen, mainly at mealtimes.

Gradually they became attracted to each other. Betsan was young and pretty, Tim good-looking with a soft Irish accent.

Their mutual attraction did not go unnoticed by the fellow workers, who watched the romance quickly blossom. Betsan would often tell her husband she was going to visit her parents in the next village, when in reality she would meet Tim secretly for a summer evening far from the farm and the knowing grins of the men. More importantly, this did not go unnoticed by Betsan's flint-eyed husband.

Then came the time when hay-making was almost over. Harvest time had not yet arrived. Some of the temporary workers moved on or went back home. Usually, when one left, there was good booze-up in the pub the night before, and then the next day the man would trudge away, carrying all his worldly goods (i.e. his clothes) in a canvas dinner bag slung over his shoulder. This is when the mystery begins.

One morning, Tim's co-worker, Bruce, was in the stable getting the horses chained and ready for the day. He was on his own, which was strange. Usually Tim was the first to arrive.

Bruce wondered whether the lad was ill, or had overslept. When he had done the horses, he decided to go to the barn to find out if anything was amiss. As he was crossing the yard he met Huw. 'Where are you off to?' Huw asked.

'Young Tim, he's not started work yet. I'm going to see if he's alright.'

Huw nodded briefly, and plodded on.

Bruce opened the barn door, expecting to see Tim in the corner, where he usually slept. In fact the barn was empty. Not only had Tim gone, his bag had gone too.

Nobody saw him that day, or indeed any day after. It was the cause of much speculation by the farmworkers, as it was the day before they all got paid. Not one of them could afford to renounce a week's wages.

Bruce asked Huw if Tim had told him he was leaving, but Huw just shook his head and said 'No.' Then he stamped off.

The conversation in the pub was all about Tim's disappearance. No one had any knowledge of his movements and no one had seen him since he knocked off work the day before. Bruce was certain that Tim would have told him that he was leaving. In fact, Bruce owed him two shillings, a serious amount of money in those days.

That week, rumour and speculation were rife, both in the pub and in the sleeping lofts. Bruce said that the morning that Tim had gone missing, he had noticed the pony trap had fresh mud on its wheels, and that the pony had dirty hooves. He had washed the trap only the day before, and to his knowledge it hadn't been used.

Huw was morose and bad-tempered, looking very moody and ready for an argument.

Betsan looked as if she had been crying. She was pale and listless, not singing or smiling like she usually did.

The men had all noticed the way Tim and Betsan looked at each other, and the oldest labourer said he had come across them one day (when Huw was at the market) kissing by the pigsties, where Betsan threw the scraps to the pigs. They had both jumped

apart guiltily when he came around the corner; he had winked at them and laid a finger across his lips, meaning he wouldn't say a word. They had both smiled with relief.

The men absorbed this in silence; they had all seen the signs. Bruce broke the silence. 'So that's it then. Huw found out and threw Tim off the farm,' he said. 'Poor Betsan, I bet he's making her suffer.'

As the weeks went by and nothing was heard of Tim, it was taken for granted that he'd gone back to Ireland.

Over the weeks, Betsan grew thin and pale. Huw more moody and short-tempered, always ready for a fight, and there was no more light-hearted singing in the dairy, no more of Betsan's ready smiles at mealtimes.

Gradually, speculations and gossip died out. Other things took the place of Tim's unexplained departure. The mystery was never resolved.

Those are the facts that I took to Peggy (padded out a bit by me to make a good story).

She became sure that the body she had seen was Tim's; she was sure he'd been murdered by Huw in a jealous rage. I was inclined to agree with her. Remember that the body had blood on its forehead – could that have been done with a shovel-blow to the head?

Irish labourers were always coming and going; no one cared very much. If we'd had any dates to go on, we might have tried looking through the archives, but all we had were old rumours and gossip. We couldn't even pinpoint the year. So Peggy and I were left with a ghost story that had no explanation. Or so we thought.

A couple of months later, I was leaning on the gate of the very same field with a farmhand who had just let the beasts in from their winter quarters in the yard. They galloped about, delighted at their freedom, charging up and down and sniffing at the grass.

I told Derrick the story and explained that most of the labourers were long dead or had moved away. I had barely finished the story when Derrick astounded me by saying, 'Oh, I know who you mean, I've seen him!'

I gasped at him, wondering if he was pulling my leg. 'Who?' I asked weakly.

'The young chap you're talking about. Black curly hair and blood on his forehead.'

'Where?' I still wasn't sure if he was joking.

Derrick raised his stick and pointed across the field towards Peggy's tree. 'He stands there for a minute or two, usually late on an August afternoon.'

I nearly choked. 'What does he do?' I asked.

'Nothing, just stands there for a minute, and then sort of fades away.'

He turned and looked at me as I stood beside him, absolutely speechless.

'I think the foreman… What did you say he was called?'

'Huw.'

'Well, I think Huw belted him over the head and killed him, then brought the body here when he'd dug the grave. Probably hid it somewhere until the coast was clear.'

'But he couldn't have dug a grave all on his own *and* got the pony and trap and loaded the body in and buried it all on the same day or night. Could he?'

'Why not? They say he was stocky and strong, don't they? And guilt would make him move.'

He stopped as if something had just struck him. 'Did your friend... What was she called, Peggy?'

I nodded.

'Did she say he only brought the body?'

I nodded again.

'No bag? With his clothes in, that sort of bag?'

This time I shook my head.

Derrick twirled the end of his stick into a bunch of new nettles. He didn't say anything, just stood thinking. Then he nodded slowly to himself, and said, 'Well that's another little mystery you've sorted out for me, Bunty *bach*!'

'What little mystery?' I asked curiously.

'I'll tell you,' said Derrick, turning around and leaning on the gate. 'My great-granddad was a well cleaner. Everyone had a well or a pump in those days, for fresh water. There would be a public one in the village for all the villagers to use, and every farm had a well of its own. Sometimes they were inside the house, in the dairy to keep the milk cool – with a wooden top on of course – but mainly they were in the farmyard. Wells used to go green, mostly in summer, and the well cleaners were kept busy. They had special well-brushes and buckets and things. One day my great-grandfather and my grandfather, who was only a lad at the time, were cleaning out the well at the farm here, and what should they bring up but a rotten old canvas bag that someone had thrown in. It was so old and rotten that it nearly fell to bits when they lifted it out. In it were the remains of some man's clothes – shirts and things. They threw it away, but they couldn't understand why it had been thrown in, and who had done it.'

He looked at me seriously. Then he said, 'I think we know, don't we? It's come to light after all these years!'

I stood there without saying anything, looking across at the tree, imagining what may lie near it.

So there you are, Peggy. I haven't given your secret away, but if anyone who lives near Amlwch Port sees the figure of a young man standing near to a mature tree late on an August afternoon, well...

Monkey Puzzle

Mr Arthur Roberts of Holyhead has sent me some good stories, and here is one of them.

In 1984 he bought a house in Cumbria Street, Holyhead, which needed a bit of renovating. As he put it, it was like going back in time to the early 1900s.

He said that when he opened the front door for the very first time, the first impression he had was a feeling that someone or something still lived there. It was as if someone had just left the room that he was entering.

The house itself, however, had a very friendly atmosphere. He described it to me. All the paintwork was brown and there was no running water, just a standpipe with a large brass tap outside. Built at the end of the house was a wash house complete with mangle, rubbing boards and a large cast-iron boiler in the corner. In the late 1880s, the house would have been extremely modern.

Being a builder, Arthur realised that a lot of work needed to be done. He went around the house, mentally tabulating each job, until he finally climbed the steep stairs to the attic.

The only furniture in the attic was an old wheelchair, which was full of woodworm. Arthur decided it would be better in the backyard, where it could be chopped up for firewood.

It was a very awkward thing to carry down the steep and narrow attic stairs, then down the main staircase into the yard. It was a feat that meant a lot of effort and quite a bit of swearing before it was accomplished. Leaving it in the backyard, he went back in, and slammed and bolted the back door.

He returned a few days later with his elder brother, who wanted to look around the house. This they did. With a puzzled air Arthur's brother remarked, 'I feel as if someone still lives here.'

Arthur shrugged, and they went up the steep attic stairs and opened the door. The first thing he saw was the old worm-eaten wheelchair, back in its place in the corner.

He stopped and stared at it.

'I don't believe this,' he said, flabbergasted. 'See that chair? Last week I carried it down and put it in the backyard, and now here it is again!'

'Someone must have been in,' said his brother.

'No chance. All the doors are locked and bolted.' Arthur was staring at the chair. 'How on earth?'

'Well, we'd better cart it down again,' said his brother. 'Are you sure you moved it, or did you just dream it?'

Arthur glared at him. 'Of course I didn't dream it. Come on, give me a hand. It won't go down by itself.'

His brother grinned. 'Why not? It came up by itself.' He still didn't believe Arthur.

Together they manhandled it down the stairs and into the backyard. 'Now you just stay there,' Arthur's brother warned, wagging his finger at it. 'No more creeping back up to the attic.'

Arthur was not amused, he was profoundly puzzled. During the next three months, all of Arthur's spare time was spent at the house in Cumbria Street.

He completely gutted the house, installing a bathroom, a new kitchen, a central heating system and so on. Always, when he opened the door, he got a feeling that the house was occupied. It was not the dead quiet feeling of an empty house, but rather as if someone had just gone into another room, leaving behind a current of moving air.

By November, most of the work was completed. He moved in. The atmosphere was still friendly and welcoming, as if someone or something in the house approved of him.

That was when strange things began to happen. One Saturday afternoon, he was busy pink-plastering one of the kitchen walls. The procedure was: open the new bag of plaster, put the pink powder into a bucket of clean water, add a scoop of plaster, and mix it all together before applying it. It was hard work, and he was soon more than ready for a *pannad* (i.e. a cup of tea).

First of all he washed his trowel and board and put them both on top of his mortar stand before he made his cup of tea. He decided to drink it outside as it was a calm, warm day, so he picked up his tea and a packet of chocolate biscuits. He turned to the back door and saw something grey and fluffy shoot under the table.

A cat, he thought. How the heck did that get in? So he put down his cup, and bent to look under the table.

'Puss, puss, puss,' he said softly, but there was no response. No response because there was no cat. He looked all over the place, and couldn't see a thing. He assumed his eyes were playing tricks on him, so he gave up, picked up his tea and biscuits, and went outside to sit on a bag of sand in the sunshine.

After about fifteen minutes, he reluctantly decided it was about time he went back to work. So in he went to start again.

One problem – he couldn't find his trowel. He knew he had washed it with his board and he could remember putting them both on his mortar stand, so he looked carefully around in case it had fallen off.

There was no sign of it anywhere. Being a professional builder, he went to get the spare he always carried.

It was time to make some more pink, so he got his scoop and dug it deeply into the untouched new bag of plaster, and as he did so, the scoop encountered something in the plaster and stopped dead. Arthur groped inside the bag to find out what had stopped the scoop and drew it out. It was the trowel. When he pulled it out and stared at it in surprise, there was a delighted squeak. He stared around the kitchen, but he couldn't see a thing.

That was the start. Over the next few months Arthur's tools would vanish from where he was using them. Days later he would find them in a completely different part of the house. Every time he found them and picked them up, he'd hear this little squeak but had no idea what had made it or where it had come from.

Odd things continued to happen. Arthur would find cans of peas in the bedroom and spot the toilet brush standing next to the pedal bin in the kitchen. Nothing nasty – it was just things being moved from where they belonged.

When Arthur told his mate, he was told it sounded like a poltergeist, especially with electric light bulbs being lifted out of their holding pendants in the centre of the bedroom ceiling and carefully placed on beds or cushions. Arthur decided to try to find out who had lived in the house before him.

Mrs Hughes, who had lived in the street for many years, was a mine of information. She told Arthur that a family called Reynolds had been living in that house when she had moved to the street, and that they had lived there for many years afterwards. 'Mr Reynolds was a sailor who had travelled the world. He once returned home with a small monkey sitting on his shoulder. It was a present for his wife, and she grew to love it dearly. It was a very affectionate little animal and had great fun with the three Reynolds boys.

'Sadly, Mr Reynolds died. As a widow, Mrs Reynolds had to bring up the three boys. When the Second World War started, they all enlisted.

'As they were all sent abroad, she was kept busy writing letters to them – all the local news, plus what the monkey had been up to.

'Within three years, they were all killed, leaving their mother, once a very busy lady who had cleaned and cooked for them all, broken-hearted, with only the little monkey to love and care for. In the course of time, even the monkey died. He was buried in the garden.'

Soon Arthur took hardly any notice of the missing articles and the squeak that he heard every time he discovered something had been moved from its rightful place. He was in for a surprise when he had a conversation with a workmate called Harold, who asked Arthur how the house was coming along.

'Fine,' he said. 'Not much more to do now.'

'So, the monkey's left you alone then?' asked Harold.

'What?' said Arthur, puzzled.

'I was a telegram boy in the 1940s. It was the only means of long-distance communication in those days. I had to carry good news and bad. I hated going to the Reynolds house though. As soon as someone opened the door, the monkey would jump

out and grab my hat, and then it would leap back into the house. I had to go in and chase it all over the place. It used to hide, and then it would take me ages to catch it. It could move as quick as a flash, with me pounding after it, up and down the stairs, into every blessed room.

'That meant I was late delivering the other telegrams. I always got a telling-off when I got back to the telegram office. God! I used to hate that monkey!'

The monkey's ghost explains the squeaks and most of the moving objects, but what about the bedroom light bulbs? Not even the most agile of monkeys could do that. And who moved the worm-eaten chair? No monkey could carry that back up to the attic. If it wasn't the monkey, who or what was it?

The Victorian Family

A lady who wishes to be known as Mary telephoned me from Amlwch, with a quite remarkable ghost story. Here it is.

When Mary was a small child, she once travelled with her family by train to Saltney via Crewe and Chester. To Mary's delight, when they arrived at Crewe railway station they went into the buffet bar for a pot of tea and sandwiches. The room was warm and steamy from the huge tea urns, and Mary pressed her nose to the glass-sided counter, behind which were piled fresh sandwiches, cakes and biscuits of all varieties. They made her mouth water.

Mother waited for the pot of tea, sandwiches, orange juice for Mary and cakes for all. Mary and her father found a table nearby. She sat down and looked around at the tables and the flow of passengers who had either just got in or were killing time until their train arrived. Mary's family were on their way to visit her aunt, uncle and family in Cheshire. As it was her first train journey she was quite excited.

There was a family party just like them – a mother, father and little girl – at the table next to them. Mary stared, as did the other girl.

Mary tugged at her mother's sleeve and said, 'Look at them, Mam. Look what they're wearing. They look like the people on a Quality Street tin'.

Mary's mother was busy with the tea things, and hardly listened to what Mary was saying. But Mary was intrigued by the family at the next table, especially their manner of dress. Although it was a very warm summer's day and women were wearing thin cotton dresses or blouses and skirts and the men and boys were in their shirt sleeves, the family at the next table were attired in heavy winter clothes.

The mother and father were standing behind the little girl, who was sitting down and staring at Mary. The little girl had a bonnet on, made of a soft dark-blue material like velvet. It rose into a high, broad brim at the front and was tied with dark ribbons under her chin. From the back there cascaded many ringlets of light brown hair, intricately curled.

She wore a thick dark jacket, buttoned to the chin. Mary could not see her skirt or boots – these were hidden by the table – but what Mary could not take her eyes off was the fur muff that the girl's hands were thrust into, which completely hid them. The muff was suspended by a cord, which went around the child's neck.

The mother was dressed in the same style. She had on a hip-length jacket of wool trimmed with a high fur collar and fur around the sleeve tops and along the front fastening and the bottom edge. She had a matching muff, but her hands were free. On her head was a small low bonnet that also tied under her chin.

Mary remembered the father's black top hat, and a long jacket or coat with black velvet lapels. He was holding the back of the little girl's chair with a hand covered by a pale glove.

All three were dressed for a very cold day, in thick winter clothes, yet it was the height of summer – a very warm day indeed.

'Look at them, Mam,' said Mary, but was told by her mother to drink up her orange squash as they would have to hurry and visit the toilet before catching the Chester train, which was due any moment.

As they left the buffet, Mary threw a glance back over her shoulder. The little girl, hands still jammed into her warm muff, had turned her head to watch Mary leave, but the child's parents seemed to be gazing across the buffet.

She never forgot these strangely dressed figures, and couldn't understand why her parents hadn't seen them. In fact she got the impression that they thought she was making the whole thing up.

Years later, she opened the *Liverpool Daily Post* and found an article about the very scene she had witnessed.

After being told by more than one observer of the haunted buffet, the reporter described the very people Mary had seen, including the clothes and their positions. He asked if anyone else had seen the Victorian family on the North Wales train route – 'If so would they please get in touch?'

Mary didn't – and has regretted ever since. She wanted to know why only the little girl with the muff was aware of her, why her own mother and father – and everyone else in the railway buffet, for that matter – hadn't see the Victorians.

I've tried to trace the article, but without knowing the year it appeared, I've had no luck. Perhaps someone reading this may have seen the Victorians. If you have – please let me know. I'd love to hear more, wouldn't you? I've heard about many trains being late arriving at Crewe, but I think the time these particular would-be passengers have waited is a record.

Old Jessie

One day our coalman, Geraint Glo – who knew about my great interest in the fast-disappearing folklore of Anglesey – asked Walt and me if we would like to go with him and drive into the centre of the Island to meet an old friend of his and photograph her house.

We agreed eagerly, and the next day we piled into his car and drove to the beautiful spot known as Parco. After about thirty minutes' drive, Geraint turned down a pretty, pot-holed lane thick with trees and said, 'Well, here we are, you are now looking at the last of old Anglesey. When this building has gone, there won't be anything left of the old way of life. It will have gone forever.'

He stopped the car, and we all looked out. I thought we'd stopped at a ruin. It was a single-storey cottage that must have been falling into disrepair for years.

The roof slate was fairly sound on the cottage itself, but the outbuilding attached to the house had gaping holes. It looked as if it were about to collapse at any moment. As far as I could see, it hadn't been touched since it was built.

The outbuilding looked as if it had once housed a milking cow and a pig – standard livestock for most of these little old cottages in the seventeenth century. At one time it must have been thatched, but the only remaining thatched cottage on Anglesey is at Bull Bay.

Geraint got out of the car. As he slammed the door shut, a short, stout, grey-haired lady appeared at the cottage door, looking to see who her visitor was. At sight of Geraint, her face broke into a broad smile, and she greeted him with a torrent of Welsh.

Walt had got out of the passenger side, and Geraint introduced him with a wave of his hand. 'This is Walt,' he said in English, 'and this is Bunty. Meet Jessie.'

Geraint asked her if she would mind if Walt took some snaps of her and the old cottage. He asked in Welsh and she replied in Welsh. Our Welsh was about as limited as her English, so we were all glad of Geraint's presence.

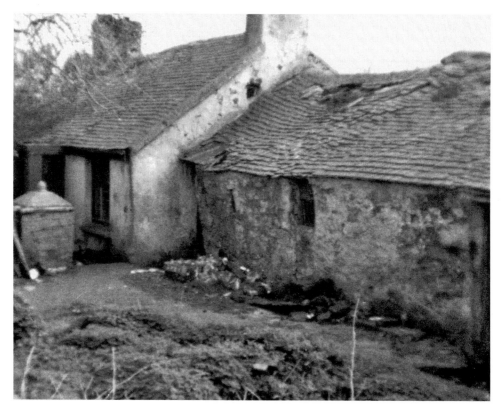

'The outbuilding attached to the house had gaping holes. It looked as if it were about to collapse at any moment.'

She didn't ask us in, so while she talked avidly to Geraint, Walt positioned himself for different shots. I stood by the car and looked around.

There had at one time been a small garden in front of the house, but it had been buried under thriving clumps of nettles. Saplings had grown up in the midst of a wasteland of rubbish. I don't think I had ever seen so much domestic refuse in my life; it reminded me of a landfill site. There were dozens of empty milk bottles, newspapers, paper bags, old tin cans... all sorts of things that had been dumped. I could see jam jars, milk crates, vegetable peelings. Some of it looked as if Jessie had stood at the door and hurled it outside; other things had been carried to the side of the house and dropped. It was everywhere, and I tried not to stare, as Jessie hadn't moved from her doorway, more or less ignoring us. Her whole attention was centred on Geraint, who was passing on the village gossip.

Eventually he finished chatting and turned to go. We all waved farewell and got back into the car. I looked back to give her a final wave through the rear window, but she had already gone back in. The almost paint-free door, which had rotted at the bottom, was firmly shut.

'Well,' said Geraint, as we set off for home, 'that is the last of the old way of life. They only had earth floors, you know? An earth toilet outside, and either a pump or

'I don't think I had ever seen so much domestic refuse in my life; it reminded me of a landfill site.'

a well, no taps inside, every drop of water had to be carried inside in pails. I wish you could have seen inside, but Jessie didn't seem to want to show it to you, and I didn't like to ask her.'

Well, that little trip happened at least ten years ago. Sadly, Geraint is now dead. Jessie, too. Walt added the photographs to his collection, and we nearly forgot about Jessie.

One day I was talking about ghosts with Pat Heaney, the wife of the vet whose farmhouse we had bought, when Pat asked me if I had heard about the ghost of the old lady who had lived in a centuries-old cottage at Parco.

She couldn't remember the name of the cottage, but the story was that the ghost had been seen by quite a number of people, and occasionally appeared to groups of curious souls who had gone there specifically to see if the story was true. Apparently the old lady was always seen by the midden in a stooping position, staring into the muck as if she was looking for something. She always faded away at the same spot.

'Was she called Jessie?' I asked Pat.

'Haven't got a clue,' Pat said blankly. 'But I can let you know next time I see Bryn.'

The telephone rang the next day and it was Pat. 'About the ghost of Parc,' she said. 'Yes, she was called Jessie. I asked Bryn, but he said she doesn't haunt the place any

more. The people who are cleaning the place have found what she was looking for – she seems to know they have – so she hasn't been seen since. She must be at rest now.'

'What was it?' I asked curiously.

'Apparently she'd hidden her life savings in a plastic bag in the midden.'

'How much?'

'£3,000 in pound notes. They were all sopping wet. They would have rotted if it hadn't been for the plastic bag they were in.'

So that's the story of old Jessie and her ghost. I never did learn the name of the cottage. And another thing – what happened to the money?

Tre-Ysgawen Hall

Anyone who has read *Haunted Anglesey* may remember the striking story of Tre-Ysgawen Hall, a very grand hotel in the middle of Anglesey that has many ghosts.

Neil Rowlands, the manager and the son of the owner, once gave us a tour of the hotel (accompanied by his black Labrador, Buster) and recounted many fascinating stories. Walt took lots of pictures that were eventually published in *Haunted Anglesey*. I have included some of them with this new story.

This hotel was at first a private house built in 1882 by the wealthy family that owned the copper mines on Parys Mountain – the Pritchard Raynors. The building that preceded the hotel on the site was burnt down in the early nineteenth century. Perhaps the haunting started then?

There seem to be many ghosts, each doing its own thing. The first we heard about was a young scullery maid who died in a tremendous fire. It began in the kitchen in the middle of a winter's night. The butler was awakened by thick smoke that made him cough. When he staggered out of bed and opened the door onto the landing he realised the kitchen was burning fiercely. He shouted and banged at the servants' doors to wake them. The whole staff, half-awake and wearing only their night attire, stumbled down the kitchen stairs and escaped by the scullery door.

It was only when they were all well away from the burning building that they heard terrified screams and realised that the little teenage kitchen maid was not with them. She was trapped in her bedroom. Her agonised screams rang out again and again until the burning floor collapsed into the inferno below and the heart-rending cries came to an abrupt end.

She has been seen many times since by the kitchen staff. As one of them said to me: 'I knew when I saw her that she was a ghost. She had on a sacking apron and a mob cap that was far too big for her, but she looked at me with such a sad look in her eyes that I didn't feel at all afraid; I was just so sorry for her. She stood looking at me for a moment or two, and then faded away.'

In the lounge before our tour, I asked Neil if he had seen her, but he said no. She sounded harmless and explicable – not like the thing that happened to him in his first year at Tre-Ygawen. This is what he said: 'We always have a senior member of staff on at night for security reasons. His first job is to go around the hotel when everyone has retired, making sure all switches are off, all doors bolted, gas and electricity supplies in order, etc. Well, one night it was my turn, and I was doing my security rounds. It was a warm night in May, I remember. All our rooms were taken, and I was walking along the top corridor.

'I was walking towards the fire doors at the end of the corridor when suddenly they flew open with tremendous force, so hard they crashed against the corridor walls. It was just as if a powerful gale had hit them and flung them back, but it was a very still, warm night, not an atom of wind. I could see the tops of the trees, and they weren't even moving.

'Not only that, but I couldn't even feel a draught around me, as I would have done if a wind had blown them open. I felt the air change until the warm corridor became icy-cold, so cold that I got goose pimples. And it was getting worse. So I panicked a bit.'

I'd been listening to this with my trusty tape recorder, and I couldn't help saying, 'A bit? I would have been down the stairs and gone!'

Neil grinned. 'Well, I must admit I did run, backwards! I didn't dare turn around! All the staff seems to have seen or heard something at some time or another – people going upstairs or downstairs and just disappearing halfway. Sometimes the receptionist sees people coming in or hears her name spoken. She says "Yes?" and looks up, but there is no one there.

'One evening the second chef and I were talking when we saw two guests come down the stairs, cross the hall, and go into the bar. It was early and the bar wasn't staffed so I got a waiter to go in and serve them. He went in, and came out a couple of minutes later to say there was no one there. There's only one door to the place, so where did they go?'

Like I said, the ghosts at Tre-Ysgawen seem to be amicable, friendly people just doing their own thing. The whole atmosphere is warm and friendly. I said this to Neil, and he said, 'Everybody who comes here says that. When we came to look at the place, it was the welcoming atmosphere that made us decide to buy it.

'On a night last January, we'd closed the hotel, and we had been deep-cleaning the whole place ready for the season – steam-cleaning all the carpets, polishing the silver, washing the curtains, washing the ornaments, doing the wardrobes and drawers, everything you can think of. We'd kept the whole staff on full-time, and we'd all been working flat out. A group of us had been working until 9 a.m. I think there were my mother and father, the housekeeper, the head waiter, my girlfriend and me. We all flopped down on chairs and settees in the lounge we're sitting in right now. We weren't saying much because we were all so tired.

'Then, all of a sudden, a noise started at that end of the room, in the ceiling. It was a slow, rumbling noise that got louder and louder as it drew nearer. It sounded for all the world like a massive kitchen table being dragged over a bare wooden floor. We couldn't understand it, as the whole hotel is thickly carpeted on every floor.

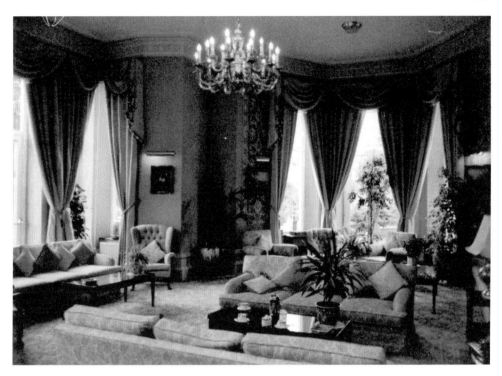

'All of a sudden, a noise started at that end of the room. It was a slow, rumbling noise that got louder and louder as it drew nearer.'

'When it was over our heads, it was so loud that the whole room seemed to shake. It kept moving and gradually died away until everything was silent. We all looked at each other as if to say, "What the hell was that?" The place was completely empty apart from us.

'Anyway, when the shock had died off, we decided to search the whole place. We went in pairs – upstairs, down to the cellars – nothing. Everywhere was quiet and normal.

'We never heard anything after that, none of us.'

Neil's big Labrador, Buster, had joined us in the lounge, and had been lying under the table on my feet, fast asleep. At this point, he raised his head, gave a single decisive bark, and went back to sleep. Seconds later, the telephone in the reception area rang, and Ian was summoned. This was the second time it had happened – Buster's bark and the ring of the 'phone immediately after.

I put it down to coincidence, but when it happened for a third time, I asked Ian if Buster always barked before the 'phone rang. If so, he must be a psychic dog. Ian looked baffled and said he had never noticed.

'Tell me something more about the hotel,' I asked.

He leaned back and thought for a minute. 'Well, when we bought the hotel in 1990, we employed a famous firm of interior decorators from London to come up and completely refurbish the place…'

'And a jolly good job they made of it,' I said.

'The top floor was the servants' quarters when the family lived here,' Ian said. 'Lots of poky, cold little rooms. We had the whole floor torn apart and made into sumptuous *en-suite* rooms for the staff. Dad and I don't live here; we've got our own houses. We only stay here when it's our turn to be on duty. So there are two single rooms for us to sleep in, very basic, but they do for a night.

'The previous owners always said there were a lot of things going on up there – noises that couldn't be explained, people talking, footsteps on wooden stairs, shouts from outside, all sorts of things. I think the alternations might have triggered something. I was sleeping over in the duty room, and I had just sunk into bed, glad to be there, when all of a sudden the room grew icy. All the sounds that an old place makes stopped, and an awful sense that something was going to happen started to grow in the cold silence. I was scared stiff; I knew something was about to happen. The hairs were rising on the back of my neck.

'Then I heard an almighty bang from the room. These two rooms each have a big pine wardrobe, and it sounded as if the one in the other room had fallen flat on its front. The walls are only partition walls, very thin, and it was very loud.

'Then the room went even colder and suddenly there was a massive *boom*, just like thunder, all around my head. I was paralysed with fright. I couldn't even reach

'These two rooms each have a big pine wardrobe, and it sounded as if the one in the other room had fallen flat on its front.'

out of bed to pick the 'phone up, even though I knew the hotel was full. I just lay there.

'Nothing else happened, even though I stayed awake with the light on all night. I was fit for nothing next day. I felt worn out. I told all the staff, but they hadn't heard a thing.

'The head chef told me that he always watched TV when he went to bed. He switched it off with the remote control, then he switched his bedside light off, and then he turned over to sleep. Every morning when he woke up, the bedside light would be on again. It happened every night, and when his wife came to stay that weekend, he told her to watch him switch it off before they went to sleep. Sure enough, it was on again in the morning.'

As he finished, Buster raised his head and barked. I nodded at Ian. 'Now watch,' I said. Sure enough, there was a discreet knock on the lounge door, and a young waiter informed Ian that he was wanted on the 'phone. Ian gave Buster a quizzical look and left the room. When he came back, he offered to take us on our tour. Buster came with us.

The place was beautiful. Every room was perfect. No expense had been spared. There was a high standard of elegance throughout.

We stopped at Room 16, and Neil unlocked the door with his master key. The room was spotless. We filed in and looked around. 'I'm showing you this room because something strange happened here a couple of weeks ago,' said Neil. 'These guest rooms

'The place was beautiful. Every room was perfect. No expense had been spared. There was a high standard of elegance throughout.'

are always kept locked. They are thoroughly cleaned after the occupant has left, and then Dad or I inspect them before they are taken again.

'Well, Dad came to inspect this one. He unlocked the door as usual, and as he went in he saw a large, green-eyed black cat standing at the side of the bed. It stared at him, then dashed across the room and hid under the dressing table. He checked that the window was closed and then went out, shutting and locking the door. The cat was a prisoner.

'Dad was furious to think someone had been careless enough to leave a cat in a guest room, so he stomped downstairs to get the housekeeper, demanding to know how the hell it had happened. He insisted she accompany him into Room 16. She was flabbergasted, and protested that when she had inspected the room after the chambermaid had finished cleaning it there had been no cat there. "Well, see for yourself then!" said Dad dramatically, flinging the door open.

'There was no cat. They searched every inch of the room, Dad muttering to himself and the housekeeper looking as if she was dying to say "Told you so!"

'Dad told us afterwards that it had looked like a real live cat and that he'd never understand what had happened for as long as he lived.'

We visited the attics where the staff lived next – all very comfortable and cleaned every day like the rest of the hotel. Ian showed us the room where the "on duty" member of management slept – the one where he had had his unnerving experience. It was pretty spartan. Walt took a snap of the pine wardrobe standing against the wall. Ian said there was an identical one in the next room, standing back to back with this one. 'We never use that room now, though – even for sleepovers.' When I asked why, he replied, 'Problems. Let me show you.'

He ushered us out to the room next door. He unlocked it and we went into a room that was identical to the one we had just left. All the furniture was the same and the wardrobe was as Ian said – back to back with the one in the room we had just left. The furnishings were exactly the same. It was spotlessly clean, everything in its rightful place. At first glance it was fairly uninteresting, and then I saw what Ian had meant by 'problems'. Flies. Thousands of them, from tiny fruit flies and ordinary houseflies to obscenely fat bluebottles. How many different species there were I couldn't tell, but they all had one thing in common. They were dead.

They covered every flat surface in the room – carpet, dressing table, bed – and not one had any life in it. I looked at them closely. Every leg and wing was motionless.

'We can't get to the bottom of this,' Ian said. 'It only happens in this room. It was thoroughly vacuumed the day before yesterday and here they are again. We've had Rentokil in, time after time. They've searched the loft and sealed it, they've had the floorboards up, they've looked for cracks everywhere. But they say they are completely baffled. The Rentokil man said he'd had some tricky jobs, but that he couldn't fathom this one at all.'

I didn't like the atmosphere in that room one bit. It sent shivers down my spine, and I told Ian.

'I know just how you feel,' he said. 'This is the room I heard the bang come from. I thought that wardrobe had fallen on its face, but everything was in its place. I'm like you; I don't like the atmosphere in here. No one does – even the Rentokil man felt it.

My mother's a medium and she says there is a man in here who is very unhappy and she thinks he is the centre of the haunting up here.'

'Perhaps he didn't like you doing all the alterations,' said Walt. 'Probably he's angry.'

'Come on,' I said, giving a last glance at all the dead flies, 'Let's get out of here.'

We turned to go down via the servant's staircase. I have never seen a staircase so steep. I felt dizzy just looking down it, and I grabbed the bannister. I wondered how poor old Buster would cope with the stairs, and I looked around for him. He'd padded happily after us around the hotel, but I couldn't see him now.

'Where's Buster?' I asked, as I crept slowly down with my eyes tightly shut.

'Oh, he will have peeled off somewhere,' Ian said cheerfully. 'He won't come up to this floor if he can help it, and he certainly won't go into that room.' He cocked his head back at the room we had just come out of. 'He'll be waiting for us downstairs.'

And there he was, standing patiently with his tail swaying slowly from side to side.

We made our departure then, sad to leave the welcoming atmosphere and friendly staff. Buster went out first, and when we got to the car he was standing by the front passenger's door. He turned and looked at us expectantly.

'Sorry old lad, you can't come with us,' Walt said cheerfully as he slid into the driving seat.

Buster stood slightly aside to let me get in, and then stood in the open doorway, looking demandingly at the glove compartment. 'Oh, of course, I should have known!' I said, and clicked it open. I rummaged about inside until found a bag containing about six dog biscuits – like little pastry-covered sausage rolls filled with goodness knows what, highly desired by dogs.

Buster took the bag gently from me in his open mouth, then, saying his thanks with shining eyes and wagging tail, he ambled back to Ian, and disappeared into the hotel.

We waved our goodbyes and set off down the drive, Walt's thoughts still on Buster. 'First time I've seen a psychic dog,' he said. 'Ian did say that sometimes Buster looks across the room and growls at an empty corner. Then after a couple of minutes he calms down, and goes across and sniffs at the place where he must have seen something. Ian was quite chuffed when Buster came to lie on your feet.'

'I'm glad Ian was chuffed. My feet went to sleep, and his head was too heavy to move. I suppose he liked me. Ian did say he had noticed that if Buster barked when a new guest walked in, Ian was going to have trouble.'

Walt grinned. 'He knows a troublemaker when he sees one. Nice dog, but a big one, I wouldn't like to tangle with him. Pity Ian can't train him up to throw out the troublemakers when they arrive. Buster the Bouncer, that's a good name for him.'

'He prefers dog biscuits, the ones like little sausage rolls,' I said, and we drove happily home.

Nellie

One day in January I was having a shampoo and set. It was being done in my front room by Mrs Ann Walduck, a small dainty lady who is a very gifted hairdresser.

It was a cold day, and at my request Ann had brought in her little dog from the car. Nellie – such is her name – is a beautiful long-haired King Charles Spaniel, with magnificent long ears that frame her lovely face like a two-sided waterfall. She is no stranger to Eilianfa as she has been here many times and was a great favourite of Walt's (he died very suddenly of a heart attack last September).

She greeted me effusively as she always did – she is a very affectionate little dog – and settled down as Ann put me under the drier and sat down herself. We chatted over a pot of tea.

The door to the hall was half-open, and suddenly Nellie turned her head that way. She got up and went to the door, looking up at someone we couldn't see. Nellie greeted it in a very welcoming fashion, her eyes shining, her long plume of a tail waving happily. She stood for a moment looking up (presumably into someone's face). Then she seemed to follow the person down the hall and into the kitchen.

Ann and I looked at each other. 'Who was that?' I wondered aloud.

'Walt!' Ann said laughingly.

We went on talking but after a few minutes Ann said, 'Where's Nellie got to? I'd better go and find her.' Ann looked in the kitchen. 'She's not here,' she called. 'I'll go and look upstairs.'

Two minutes later she was back with Nellie, who still looked happy and at ease.

'Where was she?' I asked

'In the bedroom. She was standing there looking up, as if she was looking at someone sitting on the bed.'

We stared at each other for a long moment, and then Ann said, 'People say that dogs can see things we can't, don't they? I wonder if it was Walt?'

'Do you know,' I said, 'just after Walt died, a very able plumber called Huw Williams that we call on came in and just as he closed the front door, and stood in the hall he said, "He's still here, you know." Then he nodded and smiled. It gave me a lot of comfort. I've been very lonely. Do you think he's still here?'

'I do,' said Ann.

'Well funnily enough if I can't shoot the bolt on the back door when it sticks, or get the lid off a tin, I'll say, "Help me on Walt, help me with this please." And sure enough the next time I try, it works.'

When Ann had gone, I went upstairs to put things away. In the bedroom, I saw an imprint on the fluffed-up duvet, as if someone had been sitting there.

I have written elsewhere in this book about Eilianfa being haunted. I do hope Walt is the most recent and most loved addition to its ghosts.

Unexplained

Bob is a very practical countryman, and like most countrymen who work with nature, he knows we live side by side with many unexplained happenings (in fact our distant ancestors understood many more things than we do – they hadn't been blinded by science). He told me this little story.

'When we lived at Cemlyn, on a very hot summer's day I was coming down to Cemaes for a pint to cool me off. I was coming up the hill in broad daylight and I saw a sheep standing in the middle of the road, looking at me. It seemed to be a normal sheep and I didn't take much notice, except to wonder whose it was and where it had come from. I was looking at it and all of a sudden it just vanished into thin air. One minute it was there, solid as you or me, the next, nothing!

'I was mystified, and when I got to the pub, I said to Mrs Jones, "I had a funny experience at the top of the road. I saw a sheep, as plain as daylight in the middle of the road, and it just disappeared!"

'Mrs Jones laughed, and a couple of blokes in the bar laughed. I was a bit annoyed at first, but they weren't laughing at me, you see. They were laughing because I was surprised. There are so many stories around there about things being seen and heard. For instance, for years and years people have been hearing, in Cemaes Square, the sound of a dog dragging its chain across the square, yet there is nothing to be seen. And the door of the greengrocer's shop opens and closes when there is nobody there. You see, there is a very ancient burial ground behind Tredegor, pre-Christian I believe, so all these happenings might be tied up with that.

'Anyhow, I was in the Amlwch Post Office this morning buying big envelopes for your book *Haunted Anglesey*.'

'How much do they charge?' I asked.

'Seventy pence I paid – almost as much as *you* get for your book.'

'And I bet you paid £1.40 postage?'

'You've got it! And I had to send off three! Anyway, the lady in the post office said, "Oh, I'm going to buy that book. You know so many things happen that we forget.

For instance, I was going to fetch my daughter – who works at Wylfa Power Station – and I was just a few miles from the power station, early evening it was, when I saw an old man on crutches. My first thoughts were that there must be an old folks' home around here and that I should give him a lift. But sometimes it's dangerous to give lifts to strangers, so I didn't stop. And when I was level with him, he disappeared, I was looking straight at him, very close I was, and then suddenly he vanished. He wasn't there anymore. Gave me such a shock. My hands were shaking on the wheel."

'My grandfather's brother – my great uncle – worked at Llydu Mawr,' continued Bob. 'It was a big place then, lots of people working there, and he slept in the loft above the stables with other men, and the horses were beneath.

'Every night they heard someone putting the chains on the horses, getting them ready for work. It was very plain and loud, and would have been quite normal first thing in the morning, but not in the middle of the night. But when the men went down to see what was happening, the horses would be quite quiet, mostly asleep, and nothing was disturbed. This happened every night, so in the end the men didn't bother, they just accepted it.

'Another story. Glyn Lewis Jones used to live in the farm at Llangristiolus. When he was nearly ready to retire, he built himself a little cottage by the farm gate so that his future was secure. My father used to give him a hand muck-spreading and this and that. Of course, in those days it was done with a horse and muck-cart. He was called up to the farm for dinner one day, and everyone sat down to eat around the table, master, farm workers, the girl who worked in the house, and her mistress.

'While they were busy enjoying their dinner, all of a sudden there was a tremendous crashing noise in the best room next door, as if hundreds of plates and dishes were being thrown about. My father said he could hear them breaking against the walls and being dashed on the floor. He said he stopped eating and looked around with horror, but everyone went on with their meal as if nothing was happening. 'So he said to Mrs Jones, "Good grief, Mrs Jones! You've got some damage in the room next door!"

'"Oh, we don't take any notice of things like that," said Mrs Jones. "Nothing will be amiss if you go and look."

'My father got up and went into the best room. He opened the door expecting to see a heap of broken crockery on the floor, but there wasn't a thing out of place. Everything was neat and still. So my father went back to the kitchen, where they were all finishing their dinner, and Mrs Jones looked up at him, and said, "Well, did you find anything? Was there anything amiss?"

'My Dad shook his head in bewilderment and sat down at the table.

'"We've had a lot more to put up with than things like noises," said Mrs Jones, "We don't pay any heed to them these days."

'The man sitting next to my Dad said, "You should have been here yesterday. The loaf rose up off the breadboard at that end of the table until it was about a foot in the air, then it travelled along all by itself to the other end and plonked itself down again!"

'"What did you do?" my Dad asked.

'The man shrugged his shoulders. "Nothing, what could you do?"

'All the men seemed to take the happenings in their stride, and my Dad told me they would have thought he was "soft" if he asked about them, so he shut up.

'Apparently, things went from bad to worse. The oven door was left open when Mrs Jones was baking bread, so it was all ruined. Clean dishes that had been washed were found on the draining board covered in some sort of green slime. A full tin of treacle had its lid pulled off and was pushed onto its side so that the thick treacle poured out all over the kitchen drawers – which took ages to clean up. The kitchen maid told my Dad about all sorts of things that happened, like the blunt kitchen knives being driven so deeply into the wood of the table that it took a strong man to get them out. This was done overnight – the family got up in the morning to find them all embedded in the table. The maid told my Dad that it was only downstairs where these things took place, never upstairs, and she wondered whether it was the ghost of someone who used to work there, someone angry about something.

'Finally, one night the house was set alight, and burnt to the ground, and Mr and Mrs Jones who were in bed at the time, were lucky to escape with their lives.

'Although they had lost everything, they did have the cottage, and they went to live in that. Apparently the ghost didn't follow them and the rest of their lives were peaceful.'

This story made me wonder if the Joneses had a poltergeist, but as far as I can ascertain there were no teenagers in the house, and teenagers are usually the epicentre of poltergeist activity.

Terry's Tales 1:
The Vanishing Man

We have a very gentlemanly meter-reader called Tecwyn. To us he has always been known as Three Ts. This stands for 'Tecwyn, tea and toast', since we are always happy to regale him with the latter two when he arrives. (We also have another friend known as John Three Ps – i.e. preacher, postman and poacher – but that is another story!)

Anyhow, Tecwyn gave me the name of another meter-reader employed by Scottish Power, Terry, who had quite a few ghost stories to tell me.

Terry duly arrived. He does a specialist job – he visits premises that still have electricity installed but for one reason or another are no longer paying their accounts. After we had made him comfortable, he launched into his tales.

'It's only latterly, since meeting Tecwyn, that I have realised that the things that happen in my life, things that I had taken as normal, are actually highly unusual,' he said. 'It is as if I have just woken up.'

'I'm from Llannerch-ymedd, by the way. When I was about nine or ten years old I was friends with a farmer's son from the other end of the village. His family lived near Coedana church, and I used to go there and play at weekends.

'We always thought that Coedana church was haunted. My friend told me lots of stories about the ghosts there, and I hated having to ride past there in the dark. So one winter's evening, I set off home before it grew dark, and I pedalled like hell past the church with my head down so I wouldn't see anything. I'd just got past it, round the corner, and I lifted my head up.

'Suddenly, there in front of me, not quite onto me, was an old chap. I can see him now. Black woolly jacket, waistcoat, shirt buttoned up to the top, no collar or tie, corduroy trousers, big boots, and a sickle in his hand.

'I can remember that I half-braked, half-skidded because I was right onto him. He was on my left-hand side, and I was eye-level with him. I very nearly hit him.

'His hand holding the sickle was huge, and I got a sense from him, a sense of great strength. He looked as if he wouldn't stand any nonsense from anyone. I was so startled

because we'd nearly collided. It could have been a very nasty accident. I remember thinking, *Why didn't you shout, you fool?* Even if I hadn't seen him, he must have heard or seen me coming, because it wasn't full dark, it was only dusk, and there was nothing else on the road. Surely he must have seen me coming?

I stared at him, but he didn't seem to see me, he was looking past me. He was looking over me towards the church, and he didn't say "Whoa lad!" or acknowledge me in any way. I swerved past him, corrected myself, braked, and put my feet on the ground. I looked back.

'He had gone.

'There was a hedge on each side of the road, and I thought he had leapt it. I thought to myself, *What an agile old man! He must have cleared the hedge, because I didn't hear the top twigs brushing.*

'I was a bit shaken, it had been such a near do, so I pedalled on slowly home, thinking about it. He must have seen me, so why did he start to cross the road? If he had seen me riding along with my head down, surely he would have waited till I'd gone past?

'The other thing was that he didn't make any sound on the road. He had big heavy boots on, but they didn't make any noise. Apart from the noise my tyres made on the road, everything was silent. And he didn't look at me – he was looking through me, if you see what I mean?

'I didn't go home thinking I had seen a ghost. He just looked ordinary to me, like a farmer, or a farmhand.

'I've never forgotten it; I've remembered it all my life, but it was years before I wondered whether he was a ghost.'

Terry's Tales 2: Plas Mawr

'This tale is about Plas Mawr, in Pentraeth, by the Panton Arms. Turn left onto the Beaumaris road and you will see a big house with quite a few smaller buildings around it. Once you get up the drive, you will see the big house is really a mansion. I had to go there in my official capacity.

'When I got there I knocked, but there didn't seem to be anyone in. So I went back to one of the cottages, and tried there. After I had knocked, a lady came to the door. I stated my business and she took me to the next house, where a member of the family that owned the mansion lived. When I explained to her why I was there, and that I required access, she and another lady – one young, one old – took me to the big house. They explained that the house was haunted and that the ghost hated their family. They'd had so much trouble with it that they'd had to move out. They said they'd come with me into the house but wouldn't venture far because the ghost seemed to know when a member of the family entered and would manifest immediately.

'I was too gobsmacked to ask any questions, so I just nodded and smiled.

'The door opened to reveal a long, dark corridor. An awful feeling made my hair stand on end. It was so cold and forbidding. Seeing the look on my face, the younger one said, "This is not the spooky bit, but this is as far as we are going."

Then they went back again, slamming the door behind them. I was alone. I stood there for a minute, gathering myself together. Then I started down this awful dark corridor, wondering if something would jump out at me any second.

'I opened the door at the end and found myself in a big bright kitchen, which was filled with the delicious smell of baking bread. At once I thought, *Electricity is being consumed here*. I looked around. Leading off the kitchen was a little scullery with hooks on the walls. I suppose it was where they used to hang pheasants in the old days.

'The two ladies had told me that the two electric meters were above the scullery door. The scullery also had a narrow staircase in it – obviously the servants' stairs. The ladies had warned me very forcibly to stay away from those stairs.

'I pushed the scullery door wide open, and the air in there was absolutely freezing – such a contrast to the warm kitchen.

'I looked up and sure enough there were the two meters above the door. I couldn't read them because I'm so tiny [Terry is a former jockey]. The only option was the stairs that I had been told to stay away from. I wasn't high enough to read the meters until I was three stairs up. I looked upstairs and it was pitch-black, even though the sun was shining outside.

'I put my foot on the first stair, and it started getting cold. The higher up I went the colder it got.

'I had just reached the third stair when the scullery door slammed shut. I nearly jumped out of my skin. My heart gave a great thump. It was such a shock, but I put the meter readings in my book, and put it in my pocket.

'I was leaning against the bannister as I did so, and suddenly it moved. It vibrated very strongly and quickly, so I stepped away from it, into the middle of the stairs. As I did so, I felt something behind me. I don't know what it was, but it was pushing me hard.

'I felt a very strong feeling of fear. I had an overpowering desire to bolt down the stairs and out of the house. I prayed the scullery door would open. I leapt down the stairs, and crossed the scullery floor pretty smartly. I grabbed the doorknob, and – thank heavens – the door opened. I nearly ran down that dark corridor and out of the door into the fresh air, where the two ladies were waiting for me. I tried to look casual, but they both gave me searching looks. "Well, did you find the meters?" the older one asked.

'"Yes, all done," I said cheerfully, patting my pocket. I wanted to ask them all sorts of things. What had I felt, and why? Who was haunting the stairs, and how long had it been going on for? Most of all, I needed a strong cup of tea to steady my nerves.

'"Well, I'll wish you good day then," said the older lady, and they turned away. I couldn't get back to my van quick enough. I was jolly glad to get away from that place and back to the busy road. I still don't know anything about it, but you ask Tecwyn. He knows more than I do.'

Tecwyn's Tales 1: Tecwyn and the Table

The next time Tecwyn came to read the meter (he's a very expensive friend to have) I asked him what had happened to him at Plas Mawr. First he verified everything Terry had told me, and then he began.

'Did Terry tell you about standing on the stairs and feeling something brush past him going downstairs? He said that he felt a great coldness as it was going past, but when he looked to see who or what it was, the staircase was empty. Well, whatever it was must have come from the place that had the most frightening atmosphere in the whole of the house.

'You see, the rooms at the top of the house had been made into a flat. I don't know if the rooms there had formerly been the servants' quarters, but I'm sure that flat was badly haunted. Whether that was the epicentre of the whole haunting, I don't know. Just what haunts it, no one seems to know. Perhaps only the family knows?

'The back rooms downstairs had been the living heart of the house. By that I mean there was the kitchen, scullery, pantry, dairy, plucking room, etc. – and also the servants' hall. When it was in its prime Plas Mawr was a big estate, with lots of staff, both inside and outside.

'I went into the kitchen and there stood a huge table that ran along nearly the length of the long room. It immediately fascinated me. It had obviously been built where it stood. It was far too wide, long and heavy to have been assembled outside. It must have been a couple of hundred years old, probably more. There were other things in the room too: cupboards and huge dressers with shelves built into the walls. All empty now, but at one time they would have been filled with plates, dishes, shining copper pans and kettles. I suppose all the cups or mugs they used must have hung there too – I hadn't thought about it till then, but hence the name cupboard.

'I had a good look around. There was nothing anywhere, except an old newspaper someone had thrown on the table. I just stood there admiring the table. It was plain wood that had been scrubbed daily and had turned white. Where generations of people

had sat eating there were plate-sized little hollows. Hard-working little kitchen maids must have worked hard with scrubbing brush and elbow grease to get rid of all the gravy, tea stains, and anything else that had been spilled. This was all done under the eagle eyes of cook, whose kingdom was her kitchen.

'I could still feel the strong atmosphere in the room – it was cold and resentful.

'As I was looking, I stretched out my hand and stroked the nearest hollow in the wood, and imagined how many plates of food had been laid on it over time. Then I said, "If only this table could talk."

'As soon as had I said that, the whole atmosphere changed. It suddenly became warm and peaceful, friendly somehow, and the newspaper at the end of the table started to open up slowly, page by page, as if someone was riffling through it.

'I had the feeling then that I had been accepted. I wasn't in the least afraid, and as I gathered my things together, I smiled at all the unseen presences in the kitchen. I left quietly.'

Tecwyn's Tales 2:
The Scratching Ghost

After Tecwyn had finished telling me about the table, we sat quietly for a minute, lost in our own thoughts. Then he leaned forwards towards me with a smile and said, 'I've got another ghost story for you.'

'Oh good,' I said. 'Let me get my notebook.'

When I was ready, he started: 'I trained as a teacher, you know, and as a student I had to do teaching practice.'

I groaned. 'Oh dear, teaching practice. I remember that!'

Tecwyn grinned, and continued the story. 'There were quite a lot of us, and we had to stay in a guest house in Llanfair Caer Einion. It was used mainly by students, and it was a pretty grotty place, very grubby and shabby. Anyhow, I was sharing a room with a young man who snored very loudly every night. I just couldn't sleep for it.

'The bedroom next to ours was at the rear of the house, and was much smaller, therefore it only had one occupant – Gwyn.

'After we'd been there for about a week, I happened to be alone one evening, and I was busy doing my prep for next day. While I was sitting making notes, there was a tap at the door. I shouted "Come in!" and Gwyn entered. He made a lot of small talk, but he was really there to ask me for a favour. Apparently at home he had always shared a bedroom with his brother. Now, being on his own, he found sleeping difficult, and he wondered if by any chance I would swap rooms with him.

'I didn't mind in the least. It suited me very well. I was used to sleeping in a bedroom of my own, and my fellow roommate was keeping me awake. Besides, I could do my preparations in peace. So I said yes, of course. I didn't mind swapping. He seemed very pleased and relieved by my answer, and so the deal was done. We each packed up our stuff and took up our new quarters.

'That day had been our first one on teaching practice, and as you know it is pretty stressful. I thought I would sleep like a log, and I did for the first couple of hours.

'Then I was wakened by a noise. I lay there in the dark with my eyes open, and listened. The noise was a persistent scratching. *Ah*, I thought, *it's a mouse.* I listened some more.

'*Too loud for a mouse*, I thought. *Must be a rat.* I looked at my bedside clock. It was three minutes past twelve. I'd only been asleep for two hours and there was lots of time before morning, so I rolled over, snuggled down, and prepared for a jolly good kip.

'It was not to be. The scratching persisted, and it seemed to have a steady rhythm to it. So I sat up, switched on the light, and looked around the room. Everything was normal – wardrobe, chest of drawers, dressing table, etc. Nothing was running around the floor. The scratching stopped as soon as I put the light on. So I put it off again, and lay down to sleep.

'Immediately the scratching started again. I lay still, trying to identify it, and then I realised it was coming from the direction of the dressing table.

'I listened hard, and then I identified it. It was a pen. Somebody was writing something with what sounded like a scratchy nib. There was a rhythm to the words, and very occasionally the sound of a page being turned. That was it. Someone was sitting writing at the dressing table.

'I must have sat up at least three times, and every time I switched on the light the sound stopped at once. The clock outside struck one o'clock, two o'clock, and still the noise went on, with me lying awake in bed.

'Then the clock struck three, and the sound stopped. I lay awake a long time after that, absolutely sleepless, wondering what the heck it was, but nothing happened.

'I got up in the morning, with a splitting headache. I must have looked like death. As I went in for breakfast, the first person I saw was Gwyn, who had swapped rooms with me. When he saw me, he seemed to me to look a bit shifty, so I went over to him. "Gwyn," I said, "About your room, did you ever hear anything in the night?"

'"Like what?" he asked, but his eyes never reached mine.

'"Like persistent scratching, as if someone was writing something?"

He shook his head. "No, not a thing," he said. "I've got to go and collect my stuff now." Off he went.

'The same thing happened again that night, and the next. Then it dawned on me that it started when the clock outside struck midnight and stopped when the last stroke of three o'clock died away. Needless to say, I got very little sleep that week. I wandered who or what it was, and why the sound of a scratchy nib? It sounded like an old pen, whose nib had to be dipped into ink. Had the dressing table in that position previously been a writing table?

'That weekend I went to see my previous landlady, Mrs Pritchard, who had become a great friend and happened to live nearby. I told her all about the haunting and how perplexed I was about it. She asked me about the size of the house – did I know anything about it? I had made a few enquiries, but the people who had bought the house didn't live in it – it was used by students only. Apparently they had bought other properties in the town, also for student accommodation. Apparently it was a lucrative business. So no joy there. It had been quite a select dwelling in the past, but not in this day and age.

'We discussed it for a time. We wondered if perhaps it was an earth-bound soul that hadn't moved on. She told me that some people didn't realise they were dead and went on doing the things they did when they were alive.

'It wasn't just me who had heard it – the ghost was obviously why Gwyn had wanted to swap rooms. I just wish he had been honest about it.

'After a time Mrs Pritchard said she had had an idea and left the room. When she returned she laid on the table a silver crucifix and a Bible. "Try this," she said. "Lay them on the dressing table before you go to bed. It might not work, but it's worth a try."

'I thanked her and carried them carefully back to the house.

'That night, before I went to bed, I placed the Bible on the dressing table and laid the crucifix on its cover. As I pulled the bedroom curtains closed I looked down at the churchyard then up at the church tower. The church clock read half past eleven. I got into bed, and waited for midnight, which was when the unknown writer would start.

'I listened, straining my ears for the now-familiar scratching of the pen.

'I heard nothing. Neither on that night, nor on any other. The power of the crucifix and the Bible had worked together to release the writer from the endless task.

'Who he or she was, and why they had to perpetuate the haunting, I'll never know. I don't even know how long it had been going on, but now I felt a great tide of peace and happiness in the room. The timeless scratching of the pen was never heard again.'

A Ghostly Mystery

I received a very interesting letter and photographs from Mr Arthur Roberts of Holyhead. Here is his story.

'On Saturday 10 August 1991 I moved into 10 Roland Street, Holyhead, and like most of the houses I have bought it needed renovating.

'One weekend I was taking down the old kitchen ceiling when among the bits and pieces of loose plaster, a small box, measuring roughly three inches by two, fell to the floor.

'In the evening I remembered the box. I fetched it from the kitchen and dusted it down. It was a small brown box with a hinged lid. Inside were a small red glass bead and one old-looking silver earring. Etched on the lid itself was "Mary Williams, Llanfachreath, October 20th 1856."

'I never thought much about it and kept it in a drawer.

'It was a small brown box with a hinged lid. Inside were a small red glass bead and one old-looking silver earring.'

'One Sunday later in the year I attended a christening. I came home in the afternoon. My clothes were reeking of cigarette smoke, so when I got in I went for a shower. This made me feel refreshed. Wrapping a towel around me, I headed for the bedroom but was stopped in my tracks. Standing in the doorway, with her hands neatly at her side, was a young girl. She was dressed in a maid's costume, which looked very old-fashioned, and she was no more than about five feet in height, very petite. She couldn't have been more than fifteen, and she was very pretty with a lovely smile. I just stared at her. As she smiled at me, she slowly started to fade, leaving behind her a strong smell of lavender.

'I've thought about her a lot since – but it's only recently that I have connected the date on the box, 20 October 1856 with the date of the christening, 20 October 1991. Was the little maid Mary Williams? I don't know. I still have the box.'

I wonder what value someone would give to a cheap red glass bead and an earring – was the other one lost?

The Ghosts of Eilianfa 1: Kerry Gold

I have often been asked if my house, Eilianfa, is haunted, and the answer is yes. I think the ghosts are more transient than permanent – they just seem to fade out eventually, like a photograph left out in strong sunshine. I have seen some only once, others two or three times.

For instance, before we moved here nearly twenty-three years ago (I'm writing this in 2011), Eilianfa was owned by an Irish vet, Jim Heaney, and his wife Pat – both from Dublin. They moved to the next village and we became great friends. Sadly, Jim Heaney died soon after the move and his wife not long after that.

One day when we had been here for about five years, I was washing up in our kitchen – which used to be Jim's surgery. The kitchen window looks out onto the near lawn, and I was idly wondering if I could make time that afternoon to go and sit in the warm sunshine when a movement caught my eye.

Lying on the corner of the lawn, where the high hawthorn trees meet the field wall, was a dog. I was very surprised. I hadn't seen it arrive, but there it was, contentedly lying on its tummy, paws outstretched. From the shape of its head and its gentle expression, I knew it was a bitch. Black and white, with a few touches of brown, she looked like a Collie cross.

She lifted her head to the sea breeze as it wound around the corner of the house, and I could see her nose twitching as she sorted out the many ribbons of scents that came to her. Only a dog can see the colours of the wind.

I watched her as she read the news that was being brought to her, and the half-washed plate in my hands began to slip. I looked down at it, away from the scene outside, and when I looked back the lawn was empty. The dog had gone. There hadn't been time for her to walk back across the lawn – I hadn't looked away for more than ten seconds. I was intrigued; she couldn't have been a living dog. So I dried my hands and went to the 'phone.

'Lying on the corner of the lawn, where the high hawthorn trees meet the field wall, was a dog.'

It was answered at once by Jim Heaney's widow. 'Pat,' I said. 'Bunty here. Just a question. Do you know anything about a dog that looks like a Collie-cross bitch, black and white, with a bit of brown on her? Only I've just seen one sitting on the corner of the lawn, the back one. I looked away for a minute and when I looked back she'd gone.'

I heard the intake of Pat's breath, and then she said, excitedly, 'Yes of course, Kerry Gold, our Kerry Gold, that's who you saw. Oh, she was a lovely dog. We did miss her when she died.'

'Kerry Gold,' I said. 'What a lovely name.'

'Yes, her mother was called Kerry, and when she had pups we kept one of them and called her Kerry Gold.'

'So that's who I saw,' I said, happy I knew.

'She loved that corner of the lawn. She always sat there in the sun, and so we buried her there. You'll see a slight dip in the lawn where the grave is.'

'You'll be glad to know she still sits in the sun. She is still here.'

'Oh, I'm so glad. I hope you see her again.'

I did see her again quite a few times and I even watched her slowly disappear once. That was years ago. I haven't seen her lately – maybe she's just faded out with time? Or perhaps I haven't been there when she has? Who knows?

The Ghosts of Eilianfa 2: Who Rang?

This is a strange story, and I can't for the life of me sort out the background. I've had three different versions, and I'm hoping I've got the right one. If not, my readers will soon let me know.

Apparently, during the war, Eilianfa, like many other houses away from the cities, had to take in evacuees. The evacuees were mainly children, but a few adults were also included to look after children placed where no adults were in residence.

Eilianfa was owned by a widow who loved the house where she and her husband had spent many happy years. When he died she was left with one son – a sailor who had joined the Navy. This poor lady lived alone and became mortally ill with cancer. She was taken to hospital, where she subsequently died.

She didn't want to go to hospital. She was quite vehement that she wanted to die in her beloved Eilianfa, but as there was no one to look after her she could not return.

After her death, her son (Paul is the name I have been given) was notified that the house would be invaded by refugees from Liverpool. He returned home and put all the best furniture and family items into the front downstairs room, which he then closed up, locking and bolting the door securely. Then he went back to sea.

The evacuees duly arrived, and being mainly deprived children from the slums, they proceeded to create mayhem. The adult who came with them was little better. Apparently she turned out to be one of the ladies of the night, and there are many tales of her male customers walking all the way up from Amlwch, under cover of darkness. But I digress – back to the haunting.

The children turned everything into firewood – fences, wooden gates, even the inner doors of Eilianfa's rooms, anything that would burn. Windows became filthy, covered only by blackout curtains. Gradually the once-gracious house became a wreck.

What happened when the war ended and the son returned has become blurred in people's memories, but we know it was sold. The new residents moved in and, after a lot of hard work, they restored the house to its former state of comfort.

It passed through several hands before Walt and I moved here nearly twenty-three years ago. I don't know now whether anyone experienced the haunting before us.

One night in early December, when the big winds that came straight across the Irish Sea were shrieking around the house, we were sitting before a big fire and watching TV when the doorbell rang. I got up to open the front door and a column of light, rather smoky, drifted in off the step and into the hall, where it slowly faded away.

At first I thought it was from the exhaust of a car, and stepped outside. The drive was empty – there was absolutely nothing in sight. So I went back in.

I must have looked mystified, because Walt studied my face and said, 'What's up, love? Who was it?'

I explained to him as best as I could, and he said, 'Let's have a look.' He too went out, not only to the front step, but all the way around the house. He came back looking frozen, and went to stand with his back to the fire. 'Nothing,' he said, 'no one there.'

'But you heard the bell ring, didn't you?' I asked.

'Oh yes, but that could have been the wind.'

The bell we had then was quite unusual. It was a painted metal bird (a kingfisher, I think) standing on a hollow base that housed the clapper. A length of leather about the thickness of a shoelace dangled down, and this had to be shaken to and fro to make the

'I got up to open the front door and a column of light, rather smoky, drifted in off the step and into the hall.'

round clapper clang against the inside of the bird. It made quite a jangling noise, loud enough to be heard in every room.

A week later, at about seven in the evening, the bell rang again. This time Walt went to the door. I turned the TV down and tried to listen to the voices, but I didn't hear any. A minute later, Walt came back in, shaking his head at my look of enquiry.

'Nobody there,' he said, 'and, before you ask, nothing came in.'

That week, we had our tank refilled with Calor gas, and the driver, whose name was Allan, yanked the bell so heartily it fell to pieces in his hand. We replaced it with a knocker in the shape of a fox's head made of brass, and unscrewed the broken bell.

Walt was on the 'phone one evening when we heard the old bell ring. He looked at me and I nodded and went. A full moon meant it was almost like daytime. I opened the door. There on the step was a cylinder of light, which floated past me into the hall and vanished.

I flew back into the sitting room and slammed the door behind me. 'It was that mist again,' I muttered. 'Like a tube it was, just like those tube lights you get in shops.'

'How big was it?' Walt asked.

'Oh, about five feet tall. I didn't have time to see it properly, it vanished so fast.'

Walt was thoughtfully shaking his head. 'Did you notice,' he said, 'that it was the bell we heard, even though it's been taken down? We never heard the knocker!'

We never heard it again after that, but we told our friend Derrick Rowlands about it. He heard us through with interest, and then he nodded and said, 'You're not the first to have had that experience here. Mr and Mrs Heaney saw it too. But you can't ask them now, can you? Pat Heaney had been told that it was the ghost of Mrs J——. She didn't want to die in hospital, she wanted to die here. She loved this place.'

We haven't been visited by our ghostly knocker since, and we wonder (a) if the manifestation has died out with time, (b) if it was the ghost of Mrs J——, and (c) did we let her in that last time? Is she sharing the house with us now, unseen but happy?

To Let, Furnished (With What?)

The largest employer on the Isle of Anglesey had flourished for years at Holyhead, but has now closed down due to the state of the global economy. Built in the 1960s, it was known as Rio Tinto or Anglesey Aluminium. This is a story about one of the construction workers who came from Yorkshire, told to me by his son Mr Richard Lee Van Der Daele.

'Dad came down with his workmate and they had to look for lodgings or accommodation in the village of Cemaes. It was soon found in the form of a large Victorian semi-detached villa standing next to a chapel and bearing the sign 'To Let, Furnished'. They had to deal with the estate agents – apparently the owners had moved to the mainland. The rent was very fair and the house cosy, clean and warm, so they took it and moved in. The two men congratulated themselves on being so lucky. There were many construction workers seeking accommodation, and the village was quite small.

'Throughout the first week, they were kept awake through the night by the sound of the old-fashioned lavatory system flushing loudly. On the first night each man thought the other was depriving him of much-needed sleep, but in the morning both men denied having moved out of their beds during the night.

'Another eerie thing they found unexplainable was something that happened every day. Before going to work, the men tidied up their bedrooms and the kitchen and made sure all the doors were locked when they left. Even so, each night when they returned, the bedclothes had been ripped off their beds and strewn all around the rooms.

'They talked about it between themselves, but neither man mentioned it to anyone else, mainly because my Mum, my twin brother and I – we were aged five – were coming to spend the school holidays in Cemaes, and Dad thought the unexplainable happenings might put Mum off the idea if she knew. As we would be spending quite a few weeks there, he wanted us to enjoy ourselves.

'My Mum, my twin brother and I were coming to spend the school holidays in Cemaes. Dad thought the happenings might put Mum off the idea.'

'He wasn't prepared however, for the things that happened next. In the hall stood a handsome grandfather clock, which was broken. Apparently the hands had been set at 12 o'clock. On the first night Mum went to bed later than usual. It was in fact midnight, and as she passed through the hall the hands of the clock started to sweep backwards across the face at such a furious pace that they covered twelve hours in as many seconds.

'Dad was already upstairs, and Mum flew up to tell him, and to drag him down to see. Dad knew there was something going on but, not wanting to scare her, he hadn't mentioned the flushing loo and the daily muddle of bedclothes. So he made up a story of sorts, saying the clock spring had probably been wound too tight sometime in the past, and the vibration of Mum's feet going past had somehow released it.

'She wasn't exactly convinced. "Why should it whizz round and stop at exactly twelve o'clock?" she asked curiously.

'"I don't know, I'm not a clock repairer," Dad said. "Let's go to bed."

'No more was said, but the next thing that happened could not be explained away. In the kitchen of the house was an old-fashioned clothes rack used to dry the weekly wash when the weather was wet. It was suspended from the ceiling by a rope and pulley. One evening when it had been raining heavily, Mum lowered the rack, filled it with wet clothes, hauled the load up to the ceiling, and secured the rope on the pulley.

'Imagine her astonishment when she came into the kitchen next morning to find the rack had been lowered and all the clothes flung to every corner of the room.

'She dragged Dad in to look. He didn't have an explanation, but as he was helping her to pick up the clothes, he ventured the opinion that she shouldn't tell the boys. I can imagine his difficulty. On the one hand he didn't want to scare us, but he also was trying to warn her that something was odd without scaring her too. She pondered over the clock whizzing round, and the rack being tampered with, and asked a question that my Dad couldn't answer. "Tell me something," she asked. "I knew this place was 'To Let, Furnished', but why have the owners left all their clothes in the drawers? And packets of cereal and dried fruit in the kitchen? Do you think they left in a hurry? Do you think there is something weird about this house?"

'Dad had no answer. He just lifted his shoulders and shrugged.

'At that moment Dad's mate wandered in, and Mum put the same question to him. "Bill. Have you ever noticed anything unusual about this house?" He looked blank. "I mean – anything you can't explain?"

'For a moment he didn't answer her, and Dad shot him a warning look. Then Bill grinned. "Oh, you mean those little green men that walk across my bed when I've stayed in the pub too long? No, sorry, nothing else." He picked up the paper and wandered out again, giving Dad a wink unseen by Mum.

'Dad didn't tell us till years later about having the chat with the barber when he went for a haircut. After the usual chit-chat, the barber asked Dad if he was there on holiday. When Dad told him he was a construction worker for Rio Tinto, the man asked where he was lodging. Dad explained where they were staying, and the barber paused while cutting the back of Dad's hair, looked at him in the mirror, and said, curiously, "Oh, so you're staying in the haunted house then?"

'Dad obviously wanted to know more details, but the barber didn't venture any more information, either because he didn't want to scare Dad or because he didn't know anything.

'Another thing. Mum used to take our lively Boxer dog for a final walk at about midnight. The back garden was overgrown and unkempt. A broken fence at the rear led onto a little field. As the back garden itself was quite long, the dog could wander about sniffing quite happily.

'One night quite early on in our holiday she was standing in the dark waiting for the dog when she suddenly heard the sound of laboured breathing and deep sighs. She put it down to the sound of a drunk staggering back home from the pub or something like that, so she thought no more about it and took the dog back in.

'The following night she heard the sound again and was a bit alarmed. So when the dog came back, she hurried in and told Dad.

'On the third night she told Dad that if she heard the sound again she would tap on the window and he could come and verify that he could hear it himself.

'Anyway, she went out on the third night and heard it again. She tapped at the window and Dad came out and listened. He heard it too, so he went back inside and came out with a couple of torches and a broom handle.

'They swept the torch beams across the grass where they had heard the noise, but couldn't see anything. As the grass was very long, they made big sweeps with the brush-handle, but again there was nothing.'

At this point I decided to interrupt Richard. 'Before you go any further, can you tell me what the dog's reaction was to the breathing and everything?'

'I don't remember my Mum saying that he had a particular reaction. That seems a bit odd, because animals are supposed to pick up on these things a lot quicker than humans, aren't they? I just remember my Mum saying he was as daft as a brush. For one thing he once leapt out of an upstairs window. So quite what his reaction was I don't know.

'Anyway, the point is that my Dad heard the breathing too. He said it was loud, rasping and painful, but when they started sweeping the brush around and shining the torches, it stopped. They talked about it when they'd gone back indoors with the dog, and Mum suggested that my Dad should see the two old ladies who lived next door and ask if they had been disturbed.

'He went and knocked and they let him in. He explained why he had come and asked them if they had any outbuildings or sheds. He didn't want to alarm them, but he wondered if a tramp or vagrant had set up house and he wondered if they would like him to have a look.

'They told him that they did have a shed at the bottom of the garden, and it was very kind of him to think of them. Searching around, they found a very antiquated-looking key and gave it to him. He trotted down the garden.

When he got there, the door was bricked up and had been for years. Quite where they'd got the key from, he hadn't a clue. He put it down to a bit of senility on their part.

'Anyhow, he couldn't find out where the breathing was coming from, so that was a mystery that was never solved. But it was at this point that Dad must have told her

about his previous experiences in the house – the flushing loo and the chaos in the bedrooms.

'One night, my Mum said she would love to have a night out with Dad, but someone would have to stay in with us. Dad's mate Bill went out every night to meet his mates in the pub – he was on the darts team there – so they didn't like to ask him, but Dad's foreman had been a friend for years and didn't go out much, so Dad asked him if he would babysit on Saturday night. He agreed willingly, and came dead on time. Dad introduced him to Mum. His name was Pete, and we kids liked him at once. We went up to bed, and Mum told us to be good and go to sleep at once.

'Then Mum showed Pete the pack of sandwiches she had made, and Dad started to show him how to work the TV and radio. But Pete said not to bother – he was reading a good book and he wanted to finish it.

'So off they went. We boys fell asleep, and Pete settled down in a cosy armchair with his book. All was peace and quiet.

'It was years before Mum told us the next bit.

'When my parents returned, Pete was sitting bolt upright in the armchair, his book on the floor by his feet. He was very relieved to see them, and said he was glad they were back. His first words were, "Who are your neighbours, for goodness' sake?" But before they had a chance to answer him, he broke into a torrent of words about his experience. "Are they Satanists or what? Were they having a party? Does that row happen often? I don't know how you stand it."

'Dad and Mum both looked blank. Seeing that Pete was very upset, Dad asked him what had happened. "Well," said Pete, reaching for his coat, "just after you'd gone, I was sitting reading my book and I heard a sort of low cackle coming from next door, in that room." He pointed to the wall he meant, and then went on. "It was pretty unpleasant. Then another joined in. How many people were there I just don't know, but there seemed to be quite a lot. Then somebody started shouting out loud, in a bad-tempered voice, and another one seemed to be arguing with him. I heard a woman laughing, and another one began to sob and moan. It became absolute bedlam, and it went on and on, and got louder and louder. They were all screaming and shouting and crying, and I went upstairs to see if the boys were alright. It was pretty frightening I can tell you, but they were fast asleep. It was still going on when I came down again. They sounded as if they were mad people, and I must admit they put the wind up me. I nearly knocked on the wall, but I hadn't got the guts. Who lives there, for God's sake?"

'Dad was looking very serious by now, remembering all the uncanny things that had happened. "Which wall did you hear it from?" he asked.

'"It was the room behind that wall," said Pete, pointing, "Do the people who live there know how thin these walls are? Are they only young or what? I've never heard such a noise in my life. It sounded like souls in torment. It rose to such a pitch it made my hair stand on end, and then it suddenly cut off, as if someone had switched it off. Then you came in."

'Dad then told him the neighbours in the next house were octogenarians who found it difficult to speak, never mind conduct a screaming match. And the wall through

which the tumult had come wasn't a party wall – it was the back of the house, where the back garden, the field and the yard of the chapel were.

'Pete didn't believe him, so Dad took him outside and showed him. He told his foreman about the painful breathing in the long grass. Pete was a burly, no-nonsense construction worker, but Mum said that when he came back into the house he was as white as a sheet, and visibly shaken.

'Mum told him to sit down. It didn't look as if his legs would hold him up, so he perched on the very edge of the chair, poised for instant flight. Then Dad told him about the unexplainable things that had happened – cistern flushing, clothes strewn around the rooms, clothes rack pulled down, grandfather clock going mad, etc.

'I can't remember all the details. It was ages ago when she told me, and I was only in my early teens at the time. I know that Pete was very serious when he told her that the best thing she could do would be to go back at once to Yorkshire and to take the children with her. "I don't know what's going on here," he said, "but whatever it is, it's not good, and I think it will get worse." He also said that Dad should find fresh digs as soon as possible. "I'm glad tonight's over. I've done what you asked me. But if you're still here, never ask me again. I wouldn't come into this house again if you offered me a million pounds."

'He put his coat on, and off he went. Mum said she and Dad talked about it while Dad ate Pete's untouched sandwiches, and they agreed that the way things were going it would be best if she took us home.

'I don't remember anymore. I was too young to ask questions. Did Dad find other digs, and did Bill go with him? I keep wondering about things, but it's too late now. They're both dead.

'That's it. That's all I can tell you. I've been back to Cemaes many times since. Someone still lives in the house. I keep wondering how they are doing, but now I'll never know.'

We ended our conversation there, but following Richard's directions I found the house easily enough. The barber's shop is no longer there, but the house is occupied, and it certainly wouldn't be fair on the owners to reveal its details in print. I couldn't find any history or even rumours regarding the house, but I was told by a very good source that the area had been a very important pagan site where ritual sacrifices had been made. Worked stones have been dug up from the little field at the back of the house – could the hauntings have had something to do with that? Does anyone remember the two old ladies? Why was it known as a haunted house? Has anyone else had experience there? If so, I promise to preserve your anonymity if you so wish. Nearly everyone on the Island knows me by now, so I won't be hard to find.

Stuart's Stories 1:
Poltergeist

'In around 1990 or 1991 my grandmother came to stay with us and began to suffer from Alzheimer's disease. When it got worse she moved in with us permanently. We put a single bed for her downstairs in the living room, which she used until she died there.

'One night I was in on my own. My sister was at university, Dad had gone out and Mum worked nights, so I had the cat to keep me company.

'I was watching TV when suddenly the cat started to stare at the corner where grandma's bed had been. She growled, all her fur stood on end, and her tail became enormous – all fluffed out. She began to back towards the door slowly, meowing and hissing. As soon as she got to the door, she bolted through it and along to the kitchen.

'The atmosphere had changed. It had become very heavy and threatening somehow. It made me feel very uneasy, and so I got up and followed the cat into the kitchen. She was very scared and bristly, but I picked her up and kept stroking her until she calmed down, and then we both went back – a bit gingerly – into the lounge.

'Whatever had been there had now gone. The room was peaceful again, and we could both settle down. I must admit that the whole time the cat had been staring at the corner I never saw a thing. So what had been there and what she saw, I'll never know. It never happened again.

'The only other thing I can remember that was strange was when my mother put on some rubber gardening gloves and went outside to plant some flowers at the front. When she'd finished, she came back in, took off her gloves and washed her hands. Later that day she realised that she wasn't wearing her wedding ring. She looked for it all over the kitchen and inside her gardening gloves, but she couldn't find it. So she went back out into the garden and looked in the flower bed where she had been working. It wasn't there. She was very upset about losing it. Dad borrowed a metal detector from a friend of his, and for about three days we searched all over the garden for it. No luck. Dad said he would buy her another one. They'd been married for about twenty-five years at that point. She said it wouldn't feel the same.

'She searched the whole house thoroughly – every drawer, every cupboard, places where she knew she hadn't been. But she didn't find it.

'Weeks later she was sitting on the side of the bed. She opened the top drawer of the cupboard at the side where she kept her underclothes. She wanted a white silk slip that was folded on top of all the other things. Just as she reached in to take it out, her wedding ring fell out of the air and landed on the silk slip.

'To this day she doesn't know where it came from. It just fell there. We've wondered since if it was her mother who'd found it. I just don't know.

'A few years later I got married to Elaine. We had a baby son in 2002 and bought a house in Bryngwran. It was in the Broadmeadow Estate, a row of pensioners' cottages. Some were council property, and some were privately owned. It was a row of four.

'We looked at it from the car and I said, "My God, it looks tiny, shall we just drive away?"

'Elaine said, "Too late, the estate agent's here."

'He showed us in. As we walked into the hall, we felt a really warm, welcoming atmosphere. He showed us round. It was a bungalow, with all the room doors opening off the hall. There was a sitting room on one side of the house – and behind that a bathroom and a kitchen. On the other side, the main bedroom was at the front. Behind it, a small bedroom and a tiny box room.

'It felt so pleasant. It was more spacious than we thought. We both liked it, so we bought it and moved in.

'Then things began to change. The nice atmosphere became confined to the hall, and a chill started to come over the other rooms. My wife could smell tobacco and leather boots in some of the rooms. I never smelled it, but she did.

'We felt a presence in the house. If we were sitting watching TV, I would feel as if someone was staring at me, and I would look over my shoulder. There was never anything there, of course. Then one night, out of the corner of my eye, I saw that Elaine kept looking behind her. When I asked what the matter was, she said she felt as if she was being watched. This feeling went on until after our baby boy was born.

'To begin with, he slept in a cot in the little box room we had made into a nursery, but when he'd grown too big for the cot we put him into a single bed in the back bedroom.

'He was about two then. To begin with he was very happy to be in a proper bed, but somehow he just couldn't relax in that bedroom. He was awake a lot, and very restless.

'One night, he started crying in bed. We could hear from the front bedroom that his sobs were becoming more hysterical, so Elaine and I got up and went to him. As soon as we walked into the bedroom, we could feel the atmosphere. It was cold and threatening. He put his arms up to be lifted by his Mummy.

'She walked about the room with him, trying to get him to sleep, singing to him and nursing him until he had calmed down a bit. I must tell you that he was very good and quiet when he was in the little room in his cot. No trouble. He slept all through the night. But not in this room.

'Anyway, Elaine saw he was nearly asleep, and she started to lower him gently into his bed. He woke up at once and screamed. He raised his arms to be picked up again

and kicked his legs. Tears were pouring down his face. He was absolutely inconsolable. Elaine decided he'd be better off with her, in the front bedroom, while I slept in his bed. So that is what we did.

'So I curled up in his bed, wrapped the blankets around me, and turned towards the wall. I was nearly asleep when I suddenly became aware that I wasn't alone in the room. I turned my head around and sat up.

'I'd put the light out with the pull-cord over the bed, but the room wasn't in total darkness because the street lights at the back shone faintly through the darkness. I looked all round, but of course there was nobody in the room. I could just make out the shapes of the furniture in the room. I lay down again, and tried to go to sleep, but I felt wide awake and very restless. I sat up again and looked slowly round the room. I felt as if I were being watched.

'Then I saw, in a corner empty of any furniture, a shape in the darkness. A sort of blob. It didn't have any shape, and I couldn't make out a face or eyes, but I knew that whatever it was, it was staring at me, and not in a kindly way. The whole atmosphere of the room had changed. It was heavy and cold and I didn't know what to do. So I pulled the blankets over my head and lay there, waiting for something to happen.

'Nothing did, but I didn't get any sleep that night, and I was very glad when it was light. I told Elaine all about it and we agreed to move my son back into the little room. We put his bed there and he was as good as gold. He was all smiles when we carried him into the old room, and he went to sleep right away. No more screaming and crying. We never had any more trouble from him.

'I never slept in that back room again. I wouldn't for all the tea in China. I'll never know what it was but it didn't like us.

'The bungalows had only been built since the 1970s, but the lady who'd grown up in the house and now lived across the road said they had been built on the site of some old cottages. That must have been true, because the garden at the back was a mess. I was going to make it into a lovely garden where my little lad could play, but you could only dig for a couple of inches in the soil, and then all that came up on your spade was rubble. Brick rubble, all over the garden. Whether they had piled the brick there or whether it was the foundations, I don't know.'

Stuart's Stories 2: Haunted Hangar

'I once lived in the village of Valley, and there was a hangar there, a completely rubber one. I was on early shift. I think it was about April time, about a quarter to seven in the morning on a weekday. The sun was up and the day was fine and windless. The airfield was completely silent. I was out of the building and down to the hangar first with my toolkit, ready to start servicing the jets.

'I opened the four big sliding doors of the hangar wide, so that I could get the light in. I was planning to service a jet before the tow team came in to tow it out. The jet that I had to do was at the front of the hangar on the right-hand side. There were five jets in the hangar – two in the back, one in the middle, and two at the front – using the maximum amount of space in the hangar.

'I was going around the jet with my torch and screwdriver and I came to the starboard side. The jet was a Hawk, and the colour of the Hawk is black. I'd come to the little panel on the side of the air intake, where you pump the hydraulic hand pump and where you find the jump pump brakes for towing. Now, I'd pumped the brakes in. You've got to stow the hide pump handle and lock it in with this little catch – make sure everything is secure in there and doesn't move – then you shut the flap and there are two fasteners. Remember I was at the front of the hangar. Both double doors were open, and it was a sunny morning.

'As I stood there with my back to the door, looking at the air intake, I could see the reflection of the empty airfield in the gleaming black paint of the jet. Suddenly I saw a movement in the reflected side of the plane. Someone entered the hangar through the right-hand door and passed behind me on my right-hand side. This was very clear in the reflection. A man walked across the hangar, went behind me on my right, and reappeared again on my left. I shut the panel and turned around to say hello, but there was no one there.

'The hangar was empty.

'I thought at first that it was one of my workmates, but it suddenly struck me that he wasn't wearing a high-visibility jacket – you know the bright yellow ones? We all have to wear high-visibility jackets. I thought, *Who the heck?*

'But there was no one there. From where I was, I could see right down the hangar. Then I wondered if it was possible for someone to walk behind so quickly, so I got down on my knees – the jets are two or three feet off the ground – but there were no legs or anything.

'I made enquiries later, and I found that the figure of a man had often been seen by the airmen, ground crew, etc. The story was that when the hangar was built in the early 1990s one of the builders had been working on the apex of the roof when he suddenly fell. He was killed outright.

'He's probably still there, I don't know.'

Stuart's Stories 3: The Return of Rosina

'This is another one about Wylfa Power Station. I'm telling you, Bunty, because you included the story of Rosina the opera singer in your first book.

'I had nearly finished my apprenticeship as an electrician with a local firm who worked at Wylfa. I was doing routine lighting maintenance. My job was to change all the emergency lights, whether they were working or not, every three months. I had two plastic bags, one for unused bulbs and the other for the hot bulbs. It was just twist out, twist in.

'My mate Martin and I were working together. He did one room, I did another. I was working in the south battery room. It's a very long, straight room with batteries on the right-hand side. I think they are used to start a generator in the event of a power cut.

'I opened the big double doors to the room. There are fluorescent lights in there, but I couldn't find the light switch. The emergency light at the other end of the room was still working, so I walked down the long room to put a new bulb in, leaving the double doors open. There's a fire exit at the end – I think it has a push bar on it. I took a good light bulb out of the bag.

'I felt something tap my right shoulder. No – more of a brush than a tap. I stood up and looked around and there, only two feet away, was a grey woman. Perfect. All grey. The features were perfect. I should say she was in her forties, and a bit shorter than me. Although she was all grey, I could see every detail – her head, neck, shoulders and body. Her dress seemed to fall to the floor. But as I looked at her face, I saw she had no eyes. Just two black holes where her eyes should have been. I would say it was a bit curious. The face seemed to have a slight smile. Then she vanished.

'I threw my ladder to the door and bang! I was straight out of the fire door.

'Outside the fire door was an open space with a security fence around it. There was no way I could get out. I had to go back through the room I had just bolted from. Plus, lunchtime was coming up. I had a think about it. I wedged the fire door open, went back inside, took the old bulb out and put the new one in. I had two plastic bags in one

hand and the stepladder in the other and I kicked the rock away from the fire door. It slammed shut. The only lights in the room then were the emergency light I'd just put in and the light in the main turbine hall, through the double doors. It was pitch dark in between.

'I took a deep breath and started walking calmly down the room. I suddenly thought, *What if the big doors slam shut?*

'I was about fifteen yards from the end and I just ran straight out!

'My mate Martin was standing in the main turbine hall, waiting for me. When he saw me he said, "Blooming heck! What's wrong with you? You look as if you've seen a ghost!"

'I said, "I think I have!"

'We went back to the cabin and the lads said I was white. I know my eyes were watering. I told them about it, and one of the lads who'd worked there for years said, "Oh, you've seen her then?" When I asked him what he meant, he said lots of people had seen her. They called her "the Grey Lady". I didn't have a clue, but I swore I would never go in that room again.

'A year later, we were pulling an electrical cable through the cable race and all these ducts. I was halfway between the floors, standing on the cable trail. I was the middle man, getting the cable from someone below and feeding it up to someone on the next level up. At one point I'd come to the halfway level from underneath and passed the cable up and I didn't know where I was. I thought that I needed to get to the next proper level and find a way out. I climbed up maybe six more feet or so and found an opening.

'I stepped out and found myself in the south battery room. *Oh no!* I thought, and I just walked out. I didn't dare run in case I alerted the ghost. I walked very softly. I didn't look over my shoulder or anything, I just gazed straight ahead, and oh boy! Was I glad to get out of those double doors!'

Sightings on Pentraeth Hill

Mr Mike Jones, a cheerful and very efficient plumber from Penysarn, came to repair our leaking shower tap, and he told me about an incident that happened to him in October 2010.

He was driving down the steep hill on the road from Menai Bridge, approaching the Panton Arms at Pentraeth.

Looking down along the stretch of road before him, he saw that it was perfectly empty and bounded by hedges on both sides. It was a clear autumn afternoon and visibility was very good.

Then – suddenly – a man appeared 'out of nowhere' on the left-hand side of the road, which had been perfectly empty not two seconds earlier.

'He suddenly appeared,' said Mike. 'It gave me a great shock. I stared at him as I drove towards him. He looked perfectly real and solid.

'He was a very tall man, well over six feet in height, and he was dressed in a long brown coat. He was standing still, not facing not uphill or down, but sideways. I could see he had a big beard. He seemed to be looking at the hedge, and as I approached him he moved towards it. It seemed as if he either grew much shorter, or as if he was stepping down below the surface. Then he just disappeared. Vanished as suddenly as he had arrived.

'It was so weird I went back along the same stretch the next day. I stopped the car and carefully examined the spot where he had vanished.

'The hedge was cut very thick and quite unbroken, no gaps at all, and the ground on the other side was the same level. There was nowhere he could have gone – no break in the hedge, no footpath, and definitely no steps down.'

Since Mike told me this, I have been along that stretch of road and can confirm his description of the hedge.

Another Mike, this time a Mike Turner, had visited Red Wharf Bay many times at weekends from his home in Denton. I was having a pub lunch at the Antelope and

fell into conversation with him and his jolly wife Helen. He was quite startled when I described the Mike Jones incident. He and Helen looked at each other and she said, 'There – I told you I wasn't imagining it!'

It so happened that two weeks before, they had come to Pentraeth for a weekend in their caravan. It was a Friday evening in September, and as they were driving down the hill, Helen saw a male figure approaching them on the left side of the road. 'I only saw him for a few seconds,' she said. 'I stared because he looked so odd. He was tall, with a dark beard, and his coat was so long I could only see his feet. He seemed to glide along rather than walk. I didn't have much time to see him, because he suddenly seemed to shrink – sort of collapse into himself.'

She frowned in thought, trying to find the best way to describe it. 'You know how plastic goes? I once poured hot bacon fat into a yoghurt carton. I was going to let it set and put raisins in it to feed the birds. Well, as soon as I poured the hot fat in, the plastic melted and the carton just shrivelled down until it was just a disc.' She smiled ruefully. 'I had hot fat running all over my worktop, what a mess! Anyhow, that's what the man did. He just shrivelled or melted or something – and then vanished.

'Mike hadn't seen anything. He was driving and looking straight ahead; I was in the passenger seat and the man appeared on the left, just in front of me. By the time I was opening my mouth to tell Mike, the man had gone and we were well past the spot. Mike looked back through the driving mirror, but the road was empty.

'Thank goodness you've told us about Mike Jones – I was beginning to believe my eyes were playing tricks. Mike just didn't believe me.' She looked at Mike triumphantly. 'See – it was true, I did see him.'

She asked me then if it was a ghost she had seen. Had there been an accident there – someone killed? I had to tell her that I hadn't a clue, but I would try to find out.

Well, I tried. I asked around locally and checked records, but even the police had no knowledge of a serious traffic accident at that spot. So unless someone reads this and can enlighten me somehow, our bearded man will have to remain in the company of all those ghosts who seem to be without explanation.

The Eyeless Ghost

I spent a few days in Bangor Hospital earlier this year and became quite friendly with a young houseman called Bob. He told me a terrific ghost story that he had embellished a little. He wrote it down for me for inclusion in this book (I hadn't a recorder in hospital, of course). He is a good raconteur and should have been an author. I bet he's a jolly good doctor. Naturally, I haven't used real names, but he claimed that the rest of what follows is authentic. When I asked him to confirm this, he looked at me innocently, put his hand on his heart, and said, 'Trust me, I'm a doctor!' So here it is, in his own words.

'Last year, Pete, another houseman, and I were debating how and where to spend Christmas. My parents had gone to Australia to be with my sisters. Pete had no family of his own – he rented a tiny little flat in the middle of town.

'Spending Christmas in a hotel was out of the question – we were both broke – so we thought it was a godsend when Pete got a letter from his great-aunt, his only surviving relative, inviting us to spend Christmas with her in Llangefni, the county town of Anglesey.

'He hadn't seen her for years and they only wrote sporadically. She had just bought a big, isolated house. According to Pete, she was a bit eccentric.

'I asked Pete if there was any possibility of taking Jane, my girlfriend, a nurse. I claimed that Jane was a good cook and was willing to do Christmas dinner with all the trimmings, and that we'd buy all the drinks.

'He wrote and asked Aunt Marion – she didn't have a 'phone – and she wrote back to say yes.

'We learned from one of the hospital staff that there was a good pub in Llangefni called The Bull. Llangefni wasn't far away, so that decided us. Pete said the house was big and rambling, and from what he remembered of it, it needed a lick of paint. He gave us directions to drive to Llangefni: leave town on the south road, drive through an estate of new bungalows, keep on the road until a little old stone ruin that must

have been a smithy a hundred years ago, turn up the first lane on the left, and Aunt Marion's house was in the trees. To cut a long story short, we loaded up my little old car, and set off.

'We got there after lunch and turned up the lane, which led us to the house. It had a long drive, which we lurched along. It had been at one time been covered in crushed slate, but was now all pot-holed with grass in the middle. We curved left at the top, and there in front of us was the house. I pulled up, and the three of us sat staring.

'"Needs a lick of paint?" said Jane from the back. "That's the understatement of the year! It's falling to bits!" There were weeds everywhere, covering what at one time must have been formal flower beds. There was an aura of depression and neglect about the whole place.

'We climbed up the three wide front steps – which had grass sprouting in all the cracks – and knocked smartly at the paint-peeling front door.

'We waited for what seemed an age, and just as Pete raised his hand to knock again, the front door swung slowly inwards, its hinges groaning with disuse. Musty, stale air rushed out, and my heart sank as I realised it was nearly as cold inside as it was out.

'Aunt Marion was framed in the doorway. She was a tall, thin woman with reading glasses on a cord around her neck, her grey hair in a tight bun. I didn't really notice what she wore – something black, I think. She stood unsmilingly, looking at us as if we were a group of salesmen or something. "Hello Aunt Marion!" Pete said in a jolly voice. "Long time no see!" He moved forward to give her a kiss, but she recoiled slightly, stepping back and holding the door open.

'"Peter," she said coolly, giving a formal little nod of her head, "come in." We all walked into the hall, and my heart sank even further. Rush matting, frayed and old, covered the flagged floor. It was cold through my thin town shoes. Brogues would have been more suitable for this place.

'Before us stood a wide staircase, treads uncarpeted, edged by a stout oak barrister. Doors stood on either side of the hall. To the left of the staircase, a dim passage led to the rear of the house, presumably to the kitchen area and rooms that once housed long-gone servants. A large lit oil lamp stood on a table in the hall, its old-fashioned crimson glass globe coating our faces with blood-red light. On the hall landing where the stairs bent at right angles stood an identical lamp, also lit. The hall, stairs and landing were coated in dark green distemper and were stained and blotched with damp.

'Marion turned to walk down the hall. "This way," she said, and we filed along behind her like obedient children,

'"We're in a time warp," I muttered to Pete.

'Marian paused. "Did you say something?" she asked me.

'"Er, I was just wondering why you had no electricity?" I replied.

'"Because I manage perfectly well without it," said Marion, tartly. "I find the lamps quite adequate, and I have my books and my wireless." She ushered us into a room on the right, but as she didn't ask us to sit down, we stood in an awkward little group in the middle. "Now, I'm sure you would like a cup of tea after your journey." She looked at Jane and me. "And you are?" she asked.

'Pete rushed in. "Oh! I'm sorry," he said "I should have introduced you. This is my friend Bob, and this is Jane."

'We moved to shake hands with Marion, but she just gave that cool little nod again. Our hands dropped back to our sides.

'"Ah yes, I'm sure – Jean, is it? – you will be glad to give me a hand. This way, dear." She set off for the kitchen, followed by "Jean", who narrowed her eyes as she went.

'Pete and I stood gazing around the room. It looked like a 1920s film set. There was a shiny horsehair sofa that was overstuffed and looked extremely uncomfortable, a couple of small tables that looked Victorian, two old winged armchairs on either side of the fireplace, a mantelpiece crowded with souvenirs from seaside towns, and a massive Victorian dresser adorned with hideous matching vases. In the fireplace lay a small sulky fire. It was stacked with at most three pieces of coal, seen intermittently through a pall of grey smoke. It gave out no heat; the room was icy-cold. One of the armchairs had a knee-rug on it – probably it had been thrown to one side when Marion heard us knock.

'I was frozen and I glared at Pete. "Roaring log fires, you said. A warm, cosy house, you said. Blimey, I've been warmer in the hospital morgue! And here we are, stuck for three days, unless we're all dead of hypothermia by then!'

'Pete rammed his hands in his pockets to keep them warm. "Well, I didn't know, did I? I was only a kid last time I saw her, and she didn't live here then." He wandered over to the sleet-smeared window that looked out over a back garden just as wild as the one out front. "Hey! Look!" he said. "There's a big stack of logs at the bottom. We can chop them up and have some real fires!'

'I stood beside him. "Great, yeah, as long as she's got an axe!"

'The door opened and Aunt Marion stood aside to let Jane pass her, carrying a tray of tea and biscuits. So we all sat down, drank the weak tea, and ate the old, soft biscuits. We broached the subject of the logs, and Marion agreed at once. Pete looked at me and winked – she knew it would save her coal bill.

'Later, Jane announced that she had brought some decorations and all the things necessary for a slap-up Christmas dinner, including crackers and presents for all of us. Marion thawed visibly, and smiled. Even the weather changed. The sleet stopped and a watery ray of sunshine shone through the thick grey clouds.

'Armed with Marion's rusty axe and a squeaky wheelbarrow, we went out to get the logs. Jane came with us. She was going into the woods at the back of the house, to look for some holly and ivy.

'By the evening we'd transformed the room. There was a great log fire roaring in the grate, and festive decorations adorned the walls. The smell of Jane's mince pies in the oven cheered us all up. I brought in some of the booze that Pete had stashed in the car – white wine for Jane, two bottles of Amontillado sherry for Great Aunt Marion and whiskey for me and him. We'd rather have had beer, but we hadn't yet seen the pub that was supposed to be nearby. I wondered if Marion would have a drink, but Pete assured me she certainly would if it was free. He was right.

'We had Jane's pork sandwiches and her mince pies for supper, and we all mellowed as the room warmed, and the drinks had their effect. We almost forgot what an

ice-box the rest of the house was. Our bedrooms were freezing and nobody lingered in the ancient tiled bathroom.

'At about nine o'clock, Pete got up to replenish the fire and I heard a knock on the front door. Marion was a bit tipsy – her face was flushed and she was gassing away to Jane. I don't think she heard it. "I'll go," I said, and left them in the warm room. As I opened the front door, a blast of cold wind snatched it out of my hands, and it thudded open against the wall.

'A man was standing on the step, and he walked straight in as I was still struggling with the door, trying to close it against the wind. Naturally, I took him to be a friend. He seemed very familiar with the place, and made straight for the room that they were in. I finally managed to close the door with my shoulder, locking out the cold night wind, and I followed him in. I hoped he was a friend of Marion's.

'"Who was it?" Jane asked.

'I looked around the room, but the man wasn't there. "Where's he gone?" I asked.

'They all looked at me. "Where's who gone?" asked Marion.

'I was bewildered. I'd seen him walk in as plain as day, but there was no sign. I explained to them as well as I could, but nobody else had heard the knock except for Jane.

'Marion had suddenly sobered up. "Was it a man?" she asked. "What sort of a man?"

'I tried to remember what he looked like. "He was a fairly old man with a walking stick, and I remember thinking that he must be cold, because he only had a jacket on, no overcoat, and he walked straight in as if he owned this house."

'The effect on Marion was dramatic. She went very white, and started to shake. The glass of sherry in her hand tilted, and splashed all over the carpet. She would have dropped it if Jane hadn't grabbed it and put it on the table. Marion swayed and her eyes closed. We thought she was going to faint. Pete leapt to his feet to help her, but she fell back, gripped the chair arms and said, "It's him! Oh my God! It's him!" She stared at us. "Don't go, don't go, will you?"

'We all fussed around her until she had recovered a bit.

'"Aunt Marion, what's worrying you?" asked Pete. "Who was the man, and where's he gone? Do you want us to search the house? I didn't see him come in, did you? Jane, did you?"

'Apparently, I was the only one who had seen him, but Marion believed me. She went very quiet, staring into the fire, and then she said, "Well, I'd better tell you. Bob saw him, which proves I'm not mad."

'"Do you know him?" asked Pete.

'"*Knew* him," said Marion. "He's been dead since before I bought this house." She was silent for a minute, and then she told us the whole story. "He was called Rowlands, and he and his wife bought this place when they were young. Their son was born here. They were very happy. The son grew up and got a job abroad, and the years went on. Then Rowlands's wife died, and he was heartbroken. He became a recluse, and only ever went out into the garden, where his wife's ashes were scattered. He said he wanted to die here and have his ashes scattered with hers. But the house was too much for him.

He was old and ill. His son didn't come home, couldn't care less; he had been selfish since he was a child. He didn't even care when the old man became bed-ridden and had to go into a home. Well, poor old Bill got worse, and when he knew he was dying he pleaded with his son to bring him home so he could die in the house. The son wasn't without money, but he wouldn't hear of it. 'It would cost too much money,' he said. So poor Bill Rowlands had to die in the home. I don't know what happened to his ashes – his son's solicitor looked after the arrangements – but his ashes never came back here. The run-down house was put on the market and I bought it, along with most of the furniture. An old friend of Bill's told me one day how much Bill had loved this house. In the nursing home Bill had said that whatever happened, he would come back to be near his wife." Marion picked up her glass and took a sip of sherry. "And that's what he does," she said simply.

'We were all dumb-struck.

'"You mean he haunts it? He's a ghost?" Jane asked, her eyes like saucers.

'Marion nodded. There was silence, until Pete tried to lighten the mood. "Well, at least he's a harmless ghost. He's probably glad you're here," he said, smiling at Marion.

'She lifted her eyes to his face, "He hates me," she said simply.

'"Hates you?"

'"Yes, because as far as he is concerned this is still his house, and he doesn't want anyone else in it."

'We all sat there digesting the news, and it certainly put a damper on the rest of the night. Jane escorted Marion to bed. We made plans to go into Llangefni next day, to stock up on food and drinks and to make sure things were as Christmassy as could be, ghost or no ghost. As we were going upstairs, Jane said she would just pop in and see if Marion was settled for the night. But as she reached the top, with us close at her heels, she suddenly turned around and flung herself at Pete, almost knocking him downstairs.

'"Hey! Steady on," he growled, clutching the bannister.

'"Oh Pete! He's there, he's there!" she said hysterically, hanging on to him.

'"Where? I can't see anyone."

'"By the bathroom door."

'Pete stared around. "There's no one there. You're imagining things."

'Jane peeped over her shoulder. "He's gone," she said. "But he's up here. I'm scared."

'"Oh, come on you silly goose."

'I opened my mouth to say something about ghosts being able to walk through doors, but Pete glared at me.

'It seemed as if we had a fairly good night's sleep, with no visitations, but I must admit I shot awake every time a board creaked.

'The next morning, as I made my way to the bathroom, Pete was coming out, dabbing at his chin with a blood-stained towel. He grabbed me, dragged me in, and shut the door.

'"What's wrong? Nicked yourself with your razor? Was it a new–"

I stopped talking when I saw his face. The right cheek was cut quite badly and there was blood in the sink. "He's here," Pete hissed. "I was shaving at the mirror when all

of a sudden this face appeared behind me, looking straight at me through the mirror. That's when I nicked myself. When I turned around there was no one there."

'I goggled at him. He wasn't joking – he looked grim. I looked around the empty bathroom and shivered, and then I put my hand on his shoulder. "Don't go, hang about till I've finished," I said.

'It was a horrible morning, thick dark clouds threatening snow and a cold east wind blowing. We were all a bit quiet over breakfast. Jane and I were planning what we needed in from Llangefni – food and drink etc. – and Pete asked Marion if she'd like to come for the ride. She shook her head and said, "No thank you, I don't really feel like going out today. I had rather a bad night so I think I'll go to my room and rest for a while." She looked very pale and tired, and she had dark shadows under her eyes.

'Jane turned to me, and said, with false brightness, "Tell you what Bob, I'll make a little list of the things I want from town, and if you and Pete will pick them up from the supermarket when you get the drinks, I can stay here and make the chestnut stuffing for tomorrow. You know how fiddly it is, and I'll keep Aunt Marion company."

'I hate shopping. Jane knows I do, and I was just going to object when she kicked me under the table. "OK," I said, grudgingly, "but make sure it is a little list. I know you."

'We weren't long. We got a good stock of drinks in, and I got most of the food things on the list. Then we set off back.

'The front door was unlocked when we got back, and we struggled inside, laden with shopping.

'Hands full, I kicked the sitting room door open with my foot. The fire was so low it was nearly out, and at first I thought the place was empty, but there was a movement on the old sofa.

'A man was sitting there, hunched over the dying fire. He turned as we entered and I looked at that awful grey face.

'He had no eyes. Just holes in his head.

'As I gazed, horrified, he began to disappear. From the legs upwards, slowly, until the only thing left was his horrible blind face. Then that went too, and I was staring at the empty horsehair sofa.

'A crash behind me. Pete had dropped a box of lager. "My God!" he said. We couldn't move. We were paralysed with shock. "Where are they?" he asked.

'Then we heard Jane's voice calling. "Is that you? We're here, in the kitchen."

'We shot into the kitchen. Marion was sitting on the kitchen stool and Jane was leaning against the sink. "Oh, I'm so glad you're back," she said. "We had to come in here. He came into the sitting room when you had gone, and he sat down next to me on the sofa. Oh, it was so awful, he turned his head to me, and he's got no... he's got no eyes!'

'"Is he still in there?" asked Marion. Her hands started to tremble, and she looked piteously at Pete. "What shall we do?"

'"Have you ever seen him before, Aunt Marion? If so, when?"

'"I've only been in the house for a few weeks. I bought it furnished, as it is now. It was going very cheaply. There is no electricity and some of the furniture is at least fifty years old. It was going for a song. One evening, when I'd been here for about a week,

the doorbell rang. But when I opened the door there was no one there. Well, no one I could see anyhow. So I closed it and came back in to go on with my reading. But I had a strong feeling that I wasn't alone. I kept thinking that someone was staring at me from the other armchair, even though it was empty. I couldn't settle, so I went to bed early. I slept in the big front bedroom. When I'd got undressed and washed, I climbed into bed, meaning to read. But no sooner had I settled down than I sensed that presence again – someone or something in the room. Then, all of a sudden, I saw something moving in front of the bed, under the covers. It was as if there was a dog or something there, twisting around in little circles. I felt all of the bedclothes slowly pulled away from me. They slid away downwards, and ended up in a pile on the floor. I was terrified. I jumped up and ran out across the landing to the little room at the back. I locked the door behind me. Nothing else happened. I sat on the edge of the single bed most of the night. I didn't get much sleep, I can tell you, but I've never been back to that big bedroom again. I've stayed in the little room at the back, where I sleep now. I've thought a lot about it, and I think the big bed that I first used must have been theirs – Mr and Mrs Rowlands, I mean. He was angry that I was sleeping there."

'"You mean the big bedroom that overlooks the woods?" said Pete.

'She nodded. Jane and I looked at each other. That was the room we were using. We shared the big double bed!

'"So you didn't actually see him?" asked Pete.

'"Not that time, no. I've seen him since, though." Marion looked at us. "The first time was in the dining room. I was just carrying in a tray of tea and sandwiches for my lunch, and when I pushed the door open, there he was, standing looking out of the window with his back to me. It gave me such a start that I dropped the tray. I involuntarily glanced down at the mess, and when I looked up again he had gone." She studied our faces. "That's why I was so glad you had seen him. I thought I was going mad. I've seen him twice since then. He was in the garden the first time, standing on the lawn, and yesterday I heard footsteps coming downstairs. When I opened the door into the hall, there he was, coming towards me. The awful thing was – he had no eyes." Head in her hands now, she started to whisper. "No eyes. My God, it was horrible!"

'Jane got up, and sat on the arm of Marion's chair. "Don't worry, Marion, we're here now. We'll do something about him. We can get a medium or a priest and have him exorcised or something.'

'No sooner had the words left her lips that one of the hideous vases rose off the sideboard, flew across the room, and smashed against the wall, smithereens flying everywhere.

'The whole atmosphere changed. The room seemed charged with anger. Then another vase was propelled violently across the room.

'Marion screamed and buried her head against Jane. Pete leapt up and, grabbing both the women, hustled them out of the room. We slammed the door and dashed across the hall and into the dining room.

'We heard a couple more crashes from the sitting room, but nothing followed us, thank God. We sat in silence, listening. Marion was trembling, and it must have been half an hour later when Pete said, "Well, I don't know about you but I could do with

a drink. Shall I bring us all one?" He didn't wait for an answer – he made for the door, followed by me.

'I suppose we all drank more than we should have that night, but I must admit I felt braver for it – and so did everyone else by the look of it.

'Finally we all went to bed in great trepidation. Jane and I were frightened to death of sleeping in the big bed, but nothing happened. We slept right through the night and woke to a cold and sleety Christmas Day.

'Pete and Marion were having cereal for breakfast when we walked in. We wished each other the usual Christmas greetings, and we all decided we'd open our Christmas presents after our festive lunch. I wandered over to the top cupboard to get the cornflakes out, but Jane beat me to it. She opened the cupboard door and screamed.

'Filling the cupboard was a horrible, wrinkled face, with black pits where the eyes should be. We all saw it. It could have been a living face but for those eyeless sockets.

'Jane slammed the door shut. Nearly fainting with fright, she collapsed into a chair.

'The ghost of old Rowlands haunted us all day. He'd suddenly be crossing the room we were in, or materialise on a chair when we were all chatting. One of the worst times was when Marion went to sit down and suddenly there he was, in the chair. If it hadn't been for Jane screaming at her, she would have sat on him.

'The feeling of great rage and hatred gradually worsened. None of us would move around the house alone. We needed the reassurance of other living beings to conquer our fear. We had no appetite for a Christmas dinner, so the turkey sat uncooked in the kitchen. We all became very edgy, and silent. We heard footsteps in the bedroom overhead, and then the tap in the kitchen turned on by itself. Pete's overcoat was snatched from its hook and thrown along the hall.

'At about two o'clock in the afternoon, Pete stood up. "Well I don't know about you lot, but I've had enough," he said. "I vote we all go and stay at a pub somewhere."

'Everyone gave a sigh of relief, and it was decided. We went to gather up our things. Marion packed a weekend case. Strangely enough, the ghost didn't appear while we were packing. It was as if he knew that we were leaving.

'Marion knew where the local pub was. In fact, The Bull was more than a pub. It was a very nice hotel in the centre of Llangefni. It had plenty of bedrooms, and she was sure they would accommodate us for the night. By that time we were in such a jittery state we would have slept in the car.

'We wasted no more time packing. Our bags were in the hall, and we were all putting on our coats when we heard slow, heavy footsteps on the landing above our heads – footsteps making for the stairs. We all looked at each other, and started to move even faster. Pete opened the front door and hustled us all out. He had just taken the house keys off their hook near the door when the footsteps started to come downstairs to the hall.

'We were all on the steps now. Pete was the last one out. He fiddled with the front door keys as he went out, and stopped to listen to the footsteps coming lower and lower. He tried to assume a devil-may-care attitude. "We'll leave you to it then," he said. "Hope you enjoy the turk–"

'Before he could finish he received a tremendous push that flung him down the steps. Then the door slammed with a resounding crash.

'I caught him before he fell. We all turned to make for the car. And then there was a sudden terrific whirlwind, and we were at the centre of it. Like a small cyclone, it picked up everything on the ground and flung it into the air. Pieces of crushed slate enveloped us, and I gave a cry of pain as something sharp cut across my cheek. We tried to shield our faces from the rain of slate, stones and soil.

'"In the car, quick!" yelled Pete, and we didn't need telling twice.

'We all fell in, and Pete set off down the drive, trying to ignore the hail of stones peppering the car. As we swung around the bend at the top of the drive, I turned and looked back.

'That awful dead face with black holes where the eyes should have been was watching us from the window.'

Amlwch Bus Depot

Last Tuesday I was preparing to leave my office for the day when the 'phone rang.

The caller was Mrs Thornton, from Hazel Grove in Stockport, Cheshire. She had a short but very vivid ghost story. Last summer, she and her husband came to Anglesey in their touring caravan for a fortnight's holiday. I'll let her tell it in her own words, which, with her permission, I put on tape. This is what she said.

'Last summer, my husband and I arrived in Anglesey. We were going to explore the island. Our first stop was going to be at the heritage site at Amlwch Port. We were very tired – the Saturday traffic in North Wales in August has to be seen to be believed. We pulled into a lay-by near Amlwch, on the main Bangor road, and decided to have our tea, stay there for the night, and continue our journey the next day.

'Arthur unhooked the car. Although I had brought a lot of provisions with me, I wanted to go to the shops to buy fresh bread, milk, bacon and eggs for tea.

'So we went on down to Amlwch. We'd never been before, and when we got there Arthur asked a passer-by if there were any supermarkets in the town. If so, where were they?

'We were told to turn down the road by the side of the Queen's hotel. We would see a Somerfield. Simple enough, and it had a big car park, so no trouble there.

'Arthur waited in the car while I got my trolley. As the store was strange to me, it took a while to find everything, but I hurried, mindful of my hungry husband waiting outside. I got the bacon, milk and eggs and asked another lady where the bread was. She pointed to the back of the store. "It's up there love, you can't miss it," she said. "There's a whole aisle full of different sorts. There were only two types when I was young, brown and white, but now...' She shook her head and smiled. "I'm showing my age now, aren't I?"

'I thanked her and went along to the rear of the store. She was right. There was the bread in abundance. I picked a loaf, put it in my trolley, turned to go down the next aisle, and stopped dead.

'There, in front of me, was a bus.

'I stood and stared. There it was, large as life. A single-decker bus. A green one, standing quietly in the back of the supermarket, quite empty, with its engine switched off. I stood there, unable to believe my eyes. Then a movement caught my eye.

'The driver was in his cab. In fact, he was just getting out. He climbed out and slammed the door shut. I say "slammed the door", but it made no sound. Nor did the driver's feet as he jumped out.

'He stood and stared at me. He had his uniform hat on and I think he was wearing some kind of uniform, but I was so taken aback by the whole thing, I don't really know. He was in his forties, I should think, ordinary to look at. But while we gazed at each other, I noticed his face most of all. He looked so sad. Beaten, you know, just given up. Then he turned his back on me and went behind the bus.

'It was then I noticed that the supermarket had changed. The part I was looking at looked more like a shed. Just a big dark shed. I don't know what it was made of – wood? Or brick? I don't know, but it certainly wasn't part of the shop. I was waiting for the driver to reappear, but he didn't, and while I was trying to work out whether I was seeing things, I suddenly realised how silent everywhere was. I couldn't hear a thing.

'The aisle of the shop started to come back. First the one in front of me, with tinned food, then the one behind it with packets or something. They gradually came into view, but behind them was the roof of the garage or whatever it was. Then that went too, until it was just the shop ceiling and the lights. I was back in the supermarket. The noises and people came back. There were two lads quite near me, stacking shelves and laughing.

'I just stood there like a fool, and then I trailed down to the checkout.

'Everyone seemed quite normal, talking among themselves. I didn't say anything to anyone – they might have thought I was mad. I paid and went back to the car. I told Arthur, and he just looked at me and he went "hmm". He doesn't believe in visions, or whatever it was, so I shut up and didn't say anything else about it.

'It's been nearly a year now, and I haven't said anything to anyone, but when I read one of your books I thought I'd give you a ring. It seems to be crazy to see a bus in a supermarket – what do you think?'

It was something I'd never heard of before. It was certainly original. I was determined to find out anything I could. So I 'phoned my friend Mrs Carolyn Jones, our coal merchant's wife, who lives in Amlwch, and asked her about bus garages in Amlwch – if there were any, how many there were, that kind of thing.

'Yes,' she said, 'there *was* a bus depot in Amlwch. I think it was Crossville bus depot – green buses – but I can't remember how long ago.' She muttered a rough calculation relating to how old she was when the depot was in use, and then said it must have been between twenty and thirty years ago. She told me it stood next to the police station.

Next I asked Mr Idwel Owen, always a mine of information. He had given me a couple of good stories for my first book, *Haunted Anglesey*. His butcher's shop stood on the same road as the bus depot, so I knew he would know everything there was to know. When I 'phoned, he was on his way out to see his daughter on an errand of mercy. But he kindly put down his parcels and sat on the stairs to answer my questions.

'Yes,' he said, 'the Crossville bus depot stood on the site where the supermarket now stands.' The depot had been built of brick and the roof was either asbestos or wood – he couldn't really remember. It had no buildings beyond it; just a large, empty area that was cobbled. The fair would arrive twice a year, and it was also used for many other festivals, especially when it was Amlwch carnival time.

That is about as much as I know. I asked Mrs Thornton if she could tell me anything else about the driver, but she said she was so 'gobsmacked' by the sight of the bus that she hadn't taken much in. She said once again that she had been struck by how sad he looked.

'You do mean sad?' I asked. 'Not just tired, as if he'd just finished his shift?'

'Oh no,' she said. 'He just looked as if he had the cares of the world on his shoulders. His whole bearing looked beaten. His shoulders were slumped, and I'll never forget how he looked at me – as if asking for help. Then he just went around the back of the bus and didn't come back.' I heard her sigh, then she said, 'I wonder who he was, and what was wrong. I wish I knew.'

I told her I would try to find out, but where the heck could I start? It seemed an impossible task. There must have been hundreds of buses that had pulled up in the depot at the end of their journeys, and how many crews had come and gone?

I found out there were no murders or suicides among the Crossville employers, or at least none that the people of Amlwch could remember. The only vague clue I got was from a couple of old ladies waiting for their pensions in the post office. When I told them I was enquiring about the phantom Crossville bus and described the driver and his sad expression, they both looked puzzled.

I was served just before them, but as I turned to leave Mrs Pritchard put her hand on my sleeve to stop me. 'We've been trying to think, Bunty *bach*,' she said, 'and the only thing we can come up with is a man called Griffiths.'

'Oh good, what about him?' I asked eagerly.

'Well, it was just before the bus terminals closed down. He had come from Chester, and had lodging in Cemaes Bay. One night he came off shift at about teatime, but he never arrived back at his digs. He was away all night, and the next day an inspector from Crossville came to see why he hadn't turned up for work.

'Nobody ever saw him again. He hadn't gone back to Chester, where he had lived with his mother. They posted all his clothes and shaving things back to her, and kept in touch, but he'd just disappeared. That's the only mystery about any of the bus people we have heard of. It was a long time ago – I can't even remember which year. It was just one of those bits of gossip you hear for a day or two, and then forget. I hope that helps you a bit.' She smiled. 'Perhaps he ran away with some lady, who knows?'

Who knows indeed. If he ran away with someone, surely it would have been a bigger item of gossip? A local lady would have vanished as well. And if he was planning to elope (presuming it *was* Mr Griffiths who was our ghostly bus driver), why did he leave his clothes and razor behind?

There were no reports of suicides at the time, but for a suicide a body is needed, and the sea around Anglesey is noted for its fierceness and unpredictable currents.

Whoever he was, why did he look so sad?

Amlwch Post Office

This story was given to me when I was compiling *Haunted Anglesey* but I have only just found the tape it was recorded on. The teller was a Mrs Davies, a local business lady who asked me if I would be interested in something that had happened to her a few years ago in Amlwch. She has no explanation for it, and has told no one else – in case, as she put it, 'they thought I had a screw loose'.

I assured her that I wouldn't think that at all, and I settled her down on the settee with a cup of coffee, placing the tape recorder next to her. I switched it on, and she started her story.

'I go into the post office quite regularly, about twice a week on average, with mail from my business, and of course personal stuff.

'Early this winter, about the end of January, I came out of the shop in the late afternoon, just before we closed, to go down the road to the post office. It was nearly dark, but the street lights were on. I could see the post van, but there was no sign of the postman. I knew he must still be in the post office collecting parcels and things, so I hurried down the street and quickly pushed the door open.

'I was looking down at my letters and a parcel, which I was in danger of dropping, and when I looked up, I was in a different shop.

'It had all changed; it seemed to be smaller. You know all the things they have now? Handbags, knitting wool, needles and things? They'd all gone. There was no bank of shelves running down the middle of the room, and the counter was shorter too. I'm sure there was no grille. But it was the customers I stared at – I couldn't take my eyes off them. They looked so strange.

'There were three ladies. All of them were dressed strangely – I thought at first they were in fancy dress, or making a film or something – but then I realised how quiet it was. Not just quiet, absolutely silent. There wasn't a sound. It was just as if someone had switched the sound off the TV. Everything was going on, but soundlessly.

'The one closest to me was the strangest. She was short and stout and middle-aged, in her fifties I should think, and she looked quite poor. She had a long, thick black skirt on, and clogs! Also she had a big apron on – not the kind of apron you'd wear in the kitchen, though. This one was sacking or leather, and it covered her skirt right down to her feet. I was behind her and I could see where it was tied. She had some sort of rough black jacket on, and a cap. A man's cap. Her apron wasn't very clean, and neither were her other clothes. They looked like work clothes to me.

'The other ladies were quite young, I think. Both tall and both in pale dresses. High-necked they were, with long puffed-up sleeves. Did they call them leg-of-mutton sleeves? Perhaps they were blouses? Their skirts were floor-length, and both ladies were narrow-waisted and wearing wide belts. One skirt was straight with a flounce at the bottom, and the other was fuller with no flounce.

'It was a man serving them. I knew he was talking because I could see his mouth moving, but I couldn't hear a word. He was lifting a parcel onto some brass scales and putting brass weights on the other side. He said something to the woman he was serving, and she nodded as he pulled a big book towards him, full of pages of stamps. He tore some off and stuck them on the parcel.

'I should think he might have been in his fifties. He was middle-aged anyway, and he had a uniform jacket on. Dark blue or black, I'm not sure. He had long grey side-whiskers and a thick moustache. Would he have been the postmaster, do you think?

'He turned and must have shouted something, because a young boy came from the back. He only looked about twelve. He was carrying a big canvas bag. I think he had a uniform on. His hat was navy blue with red piping around, and the man gave him some parcels and letters, which he dropped into the bag. He looked around the customers, pointed to one young lady, and said something.

'It must have been something cheeky because the man pretended to clip his ear. But the lad dodged it and shot out of the back door again. Everyone was laughing and the postmaster was grinning and shaking his head as the young woman paid him.

'Then they all turned round and smiled and nodded. I thought they were smiling at me, but they were looking at somebody behind me.

'When I looked, somebody had just come in. He was an elderly man in a rough suit and a bowler hat. He leaned heavily on a stick.

'Behind him was a window. I could see through it a bit, and I saw a man go past on a cart. He was holding reins in his hand, and it looked as if it was morning.

'It was all dead weird. As I looked at the man going past the window in the cart, the whole picture started to go wavy, as if I were underwater. It made me dizzy.

'The whole scene was going blurred until everything became transparent and faded away. I kept blinking as it dissolved or melted or whatever, then suddenly I was back in the present-day post office. The room was long again, and the counter was at the end instead of the side. The postmistress was deep in a conversation about passports. Everything was normal; there were the handbags and things. There were the shelves of

stationary and stuff in the middle, and the young lady was behind the counter in the corner selling sweets and things.

'I needed a sit-down but I managed to stay upright long enough to get served. Then I went home and had a strong cup of tea.

'I've thought about it a lot since. I haven't told anyone else. They'll think I dreamt it, but honestly it's true!'

Llaneilian Church

Before Christianity was brought to Britain, mainly by the Romans, the Celts had established the religion of Druidism, which held sway in Britain for thousands of years. The old gods of Druidism were thought to be responsible for the life-giving forces that sustain life on Earth – i.e. air, fire, water, sunlight and earth. The remnants of this culture can be seen all over Britain in the form of stone monuments.

When Christianity arrived, it took two or three hundred years for it to become established, particularly among the Druidic hierarchy. The simplest way for one Christian to show his faith to someone he believed to be a follower of Christ was to draw a small eyeless fish in the soil or sand on which they were standing. The message, once passed on, would be easily erased with the brush of the Christian's foot.

The symbol was the Ichthys – the Greek word for 'fish' – and represented Jesus. The Christians became more numerous with every generation, so numerous in fact that Emperor Constantine had to supplement the number of British priests by sending many of the senior dignitaries and their entourages from the churches and monasteries of Rome to Britain, in order to swell the ranks.

Such a man was Eilian, the son of Alltyd Rededawy. He was a very holy man who built a church and a school for novices near what is now Amlwch. So revered was Eilian that when he died he was made a saint. The church is now known as St Eilian's.

Saturday was the Jewish Sabbath and the original day of rest for Christians. Sunday ('day of the sun') was the pagan rest day. Today thousands of Christians go to church on Sunday unaware of the fact that they are following in the footsteps of their pagan ancestors.

St Eilian's church was both a place of worship and a much-needed social centre. People would gather in the church to hear the news. The congregation didn't have the luxury of pews. Most people stood in the centre of the church, and the frail and the elderly would sit on benches around the sides ('and the weakest shall go to the wall'). Sometimes there were dog-fights and 'dog tongs' – 5-foot-long hinged brass tongs with

an open grip at one end – were used to harmlessly eject any animal whose behaviour was interrupting the service.

Over the years, the transition from paganism to Christianity was completed. The sacrificial stones on which animals were slaughtered as a tribute to the gods were abandoned and the ritual was moved into the church, where Christ, in the form of blessed wafers (signifying the body) and holy wine (signifying the blood), was eaten and drunk.

Pagans had cursing wells where they would toss coins or valuables as gifts to the gods; Christian churches had a blessing well where people could say their prayers and appeal to whichever saint the well was dedicated to. The Christian supplicants often tied pieces of cloth around adjacent trees or bushes after their pleas. Many pagan sites, however, still have their cursing wells. One near Colwyn Bay was reputed to be so powerful that it was filled in. Found in the bottom was a Roman curse written on stone. St Eilian's church still has its blessing well. It is also reputed to have a cursing well, but its location is unknown.

Nearly all of our herbal remedies date from the days of paganism. The old names tell their own story: woundwart, eyebright, feverfew, selfheal and all the rest. Valerian, now growing wild in the hedges, was brought here by the Romans. It was administered to bring calmness to an agitated state of mind, and was doled out to the Roman soldiers after a battle to settle those whose adrenalin was still aroused.

We bought Eilianfa Farm twenty-three years ago from a very pleasant Dublin-born vet and his wife – Mr and Mrs Jim Heaney.

They were both confirmed Protestants, and members of Llaneilian church. Mrs Heaney was always busy there, arranging the flowers, sorting hymn books, dusting pews, etc. She told me the following story when I asked her if she had seen any ghosts.

'Last year I was in the church one dark October afternoon, lining up the hassocks in the pews, when I suddenly started to feel uneasy and shivery. I got an overpowering feeling of being watched, although I knew I was totally alone in the church.

'At the time I was turning over a hassock so that its embroidered top was in place. I looked over my shoulder towards the pulpit, but that of course was empty. So I turned back and went on with my work.

'I could still feel eyes boring into my back, so I stood up and looked around the church. As usual, everything was still until a slight movement up on the rood screen caught my eye. Have you ever seen the rood screen?'

I nodded. 'But not very closely.'

'It's magnificent – carved and erected in the fifteenth century I believe, and very wide, about five feet at the top. Plenty of space for two or three people to walk abreast along it.

'I saw the figure of a woman standing on the top near the centre. She looked alive, proper flesh and blood, just like you or me, but she was dressed in the most extraordinary way – a bit like national costume. Long black skirt, a shawl and a black hat – a bit like a witch's hat, but it didn't go up to a point. She looked pretty old. Her hands were all knobbly and withered, and she was beckoning to me with her finger, but the most awful thing about her was the expression on her face.'

'She looked incredibly evil. That's the word I want, evil. She had eyes that peered at me, a very ugly face under that bonnet thing, and, worst of all, this finger. First she

would point it at me, and then she would flap her hands towards herself, as if she wanted me to join her.

'It was an awful shock to me. I knew right away that she wasn't a living woman. The feeling of evil she gave out terrified me.

'I dropped the hassock and flew out of the big door. As I turned to slam it shut, I looked back and the rood screen was empty. So there you are. I'll never be alone in that church again.' She shook her head sadly. 'And yet it has such a peaceful atmosphere… I don't understand it.'

'Has anyone else seen her?' I asked.

'Not as far as I know, but I was told that a farmer and his wife were at morning service on a Sunday in January one year, and the farmer fell asleep during the service. He woke up suddenly and saw a group of women on top of the rood screen, all staring down at him. As far as I can gather they were dressed like the one I saw, and they were all gazing down at him with hatred on their faces.'

Pat must have seen the expression on my face because with irritation she said, 'Before you say anything, he hadn't been to the pub the night before – he'd been up all night lambing. Anyway, he nudged his wife and when she looked at him he nodded towards the screen and she looked up at it. He could tell by the way she gasped that she had seen them too. They certainly scared her, and then they vanished.

'That couple never saw the women again, and I don't think they told many people. I wish I knew who they were – the couple I mean, not the figures. I never did find out.'

She shuddered. 'I wouldn't go there on my own for all the tea in China.'

The story made me think. Long before Pat Heaney told her tale, Walt and I had gone to the church. We roamed around the churchyard at first, taking photographs of the varied architecture.

The modern part of the graveyard is very well kept and peaceful, and we spent some time there before we ventured into unused part. It was very wild and overgrown – thorny thick brambles, tall stinging nettles, clumps of rough grass, and uneven ground. A very uninviting place indeed. It has since been cultivated, I believe.

We had been wandering around for perhaps ten minutes or so when Walt suddenly said, 'Do you know Bunt, I'll have to go back and sit in the car for a few minutes. I feel really weird.'

I looked at him. He had gone very pale and was sweating under his eyes.

'You carry on, love. I'll be OK in a minute.'

Concerned, I sat with him in the car.

'It's going off now,' Walt said. 'Don't know what happened. I felt OK one minute, and the next I felt sick and dizzy, as if I were going to pass out.'

'Do you think it was this place?' I asked. 'Most churchyards feel calm and tranquil, but this one doesn't to me. I felt very uneasy and restless. I couldn't get out of there quick enough. I was glad you felt the same way. This place feels evil to me, not holy.'

We decided to call it a day and go back home.

On the way we stopped at the chemist's in Amlwch for some paracetamol. A friend of mine, Dorothy, was waiting to be served and I explained Walt's experience in the church. It had left him with a bad headache, hence the paracetamol.

'We ventured into unused part of the graveyard. It was very wild and overgrown – thorny thick brambles, tall stinging nettles, clumps of rough grass, and uneven ground. A very uninviting place indeed.'

'Well, that doesn't surprise me,' said Dorothy. 'You want to ask my mam about the place.'

Her mam has a small caravan park near Benllech. Apparently, last year, one of her caravans was rented by three headmasters from the Manchester area, who had come for two weeks to study and explore old churches. They were quiet, polite and very inoffensive – excellent company.

One morning in their first week, over breakfast, they told her that they were going to take a look at Llaneilian church. The day was sunny and warm and they were in good spirits.

They reached the church, went in, and read the official pamphlets laid out for visitors. Then they wandered about and explored separately. After they had been in there for about fifteen minutes, one of them started shouting: 'Bill! Bill! Help me!'

Bill turned around from the brass plate he was reading on the wall and saw his friend Tony nearly on his knees, clutching desperately to the fifteenth-century oak rood screen, and gradually sinking to the floor.

He dashed along the aisle to Tony, grabbed his arms and, with a huge effort, heaved him up, and lowered him into a pew, where he sank down with his head in his hands.

It was no mean feat getting him there. Tony was over six feet tall and broad with it; Bill was a mere five foot six, and slightly built. They were both breathless, and it took them a few minutes to recover. Then Tony tottered out and sat on a gravestone until

he felt better. He asked if they could go back to the caravan, so that he could lie down. The other two ribbed him gently, telling him it was the sausage he'd had for breakfast or too many pints the night before.

But he was very serious about it. After they'd asked what happened, he said he felt alright until he'd gone behind the rood screen for a more detailed examination. 'And then I felt a terrific force,' he said, 'as if something was trying to drag me down. It was awful. I felt as if I was drowning. I couldn't escape it. It was sort of cold and evil. I've never felt anything like it before. God knows what would have happened if you hadn't come, Bill. I can't thank you enough. One thing's plain – I won't be going there again.'

He never did. According to Dorothy's mam, he lay on his bed all afternoon while his friends went out.

In the winter of last year, my friend Ann was attending a burial service in Llaneilian church. I'll let her tell it in her own words.

'I'd arrived early for the funeral, and there was only myself and a group of people in the church. I sat in a pew near the front as I'm a bit deaf, and I didn't want to miss any of the service. I had just sat down and was looking around when three men came from the vestry door area, and walked behind the font. There they stopped, and looked up towards the ceiling.

'They looked like workmen. They had rough jackets on, but I didn't notice their clothes particularly. I just wondered what on earth workmen were doing at a burial service.

'One of the men pointed upwards and said something, and they all looked up. I did too, but I couldn't see anything. I wondered what they were all looking at. They seemed to talk for a bit, and then they turned around and started to go back towards the vestry.

'That's when I noticed that one was wearing a dark knee-length cloak. They weren't wearing hats. Well, they wouldn't in church, would they? When they reached the vestry door, they suddenly started to fade away. One minute they were there, the next they weren't. It made me go cold, and I wondered if I was seeing things. I was so shocked. I wondered if the people at the back of the church had seen them, so I turned around. But just then a party of mourners came in talking, and I couldn't see the other group.

'Please don't give my full name, in case people think I'm potty!'

I've searched and asked people but I've had no luck. However, I've heard about two more sightings. Alun, a retired joiner, was once a member of a club in St Eilian's, and had this to tell me.

'My friend Bryn and I were walking past the church on a Friday afternoon last summer. It was very warm, a beautiful day, and we'd just passed a group of cyclists who were happily buzzing along. They shouted "Hi!" and said something about it being a lovely day. We shouted greetings back to them. When we turned round again we saw two figures on the road about ten yards in front of us.

They were going in the same direction as us, but we were very surprised and wondered where the heck they had come from. There was no opening or gateway that led into the road at that spot. They hadn't been there when we shouted to the cyclists, and they were walking in the middle of the road – the bikers would have hit them head on.'

'Did they look real, solid?' I asked. 'Did you see how they were dressed?'

'Oh yes,' said Alun, 'they looked real enough. They were workmen I should think. They had old clothes on, working clothes. The clothes looked a bit old-fashioned, I must admit, and they had clogs on. You don't see many clogs these days. Then they started to – what can I call it? – melt. They started to go blurry around the edges, and then their clothes became mixed up, sort of all one thing, not separate jacket and trousers. Next they went smaller and smaller, and roundish like footballs, spinning about. Then they vanished altogether, and the road was empty.

'We couldn't believe it, we just stopped and stared. We were dead opposite that gate to the left of the church then, but there was nothing to be seen. I felt my hair standing on end. I was really scared. Then Bryn said, "Let's get out of here." We turned and legged it back.

'It's the weirdest thing that's happened to me in my life. I've never believed in ghosts before, but I can't find any other explanation for what happened that day.'

'Has anyone else seen them? Have you told anyone about it?' I asked.

He shook his head firmly. 'No.' If anyone else has seen these two mystery ghosts, I bet they too have kept silent.

There are a lot of unidentified souls buried in the church grounds. In an eighteenth-century book it was written that the bodies of many drowned sailors and unidentified paupers were laid in a long trench to the south of the church. After hundreds of years of burial, the small churchyard had become full and to make more room for the local dead, this trench was later dug out. The disturbed bones were placed in an ossuary

'There are a lot of unidentified souls buried in the church grounds.'

either beside or beneath the church. Could these disturbed souls have anything to do with the atmosphere in the churchyard, or the hauntings?

The last ghost I was told about seems to be a well-known one. He was a scoundrel in his day, and his after-death appearances were at one time frequent, but are not so plentiful now.

He appears just inside the door of the church, on the right-hand side. He was a small man, and his odd movements are baffling. Apparently he faces the wall and keeps bowing and straightening, all the time looking down.

One local now in his eighties was told stories about this ghost by his grandmother, who claimed that the small man had committed a grievous sin when he was alive and this was his repentance. He committed the sin in the 1820s and died in the 1850s and was sometimes seen re-enacting the crime.

In the church, by the door, is a large oak chest, bound with brass and securely locked. In the top are three slits or apertures, made for dropping in coins. These were donations made by the pilgrims who visited the holy well, or by richer members of the congregation for the poorer people, rather like our modern poor boxes. In those days the donations were usually in groats, but very often coins of much greater value were put in.

In the late 1800s, the chest was opened weekly with great ceremony, and the cash gifts were counted before being distributed to the poor of the parish. The key was kept by the rector.

The funds were usually considerable, but one Sunday the box's contents seemed to have diminished considerably. The church officials took note of this, and after two or three weeks of abnormally low funds, they had a meeting to discuss the problem. Coins they had deliberately placed in the chest had been found to be missing when the chest was opened.

Obviously the money was being stolen, but the church door was always kept locked at night, because of the large amount of silverware the church contained. However, the door lock was simply made, and simple to undo.

The next Sunday night, two of the churchmen concealed themselves in the dark pews and heard a soft scraping noise at the lock.

It opened slowly, and they could see a man's dim form outlined by the starlight. Leaving the door open, the man crept stealthily in until he stood in front of the chest. He was carrying a taper, which he lit and jammed into the side of the chest. He then took from his pocket a long, thin, flat piece of wood. One end gleamed in the dim light of the taper.

Slowly, he bent down and slid the wooden lath into a slot on the chest. Then, as he rose up, they heard the chink of coins as he removed a couple from the end of the stick.

Again and again he stooped down. Every time he stood up, they saw that a few coins had stuck to the end of the stick. He was putting the money in his pocket.

With a roar of rage, one of the men leapt from his hiding place, closely followed by the other. But, quick as they were, he was quicker. He darted out of the open door and ran swiftly into the darkness.

They never caught him, or found out who he was, but the stick, thickly coated with pitch at one end, was found thrown into the hedge.

So that is the solution to the stooping ghost. I'd be interested to learn if anyone has seen him recently – or any other ghost for that matter.

Just as I finished this story, Tecwyn arrived to read the meter. As he was getting back into his van, he called over his shoulder, 'What are you working on now?'

'Well,' I said, 'I've got three stories ready, including a murder, but I'm writing about Llaneilian church just now.'

'Oh, that place gives me the shivers,' he said. 'I'll tell you about it one day.'

Oh no, I thought, *does that mean another book waiting?*